Giving The Bird

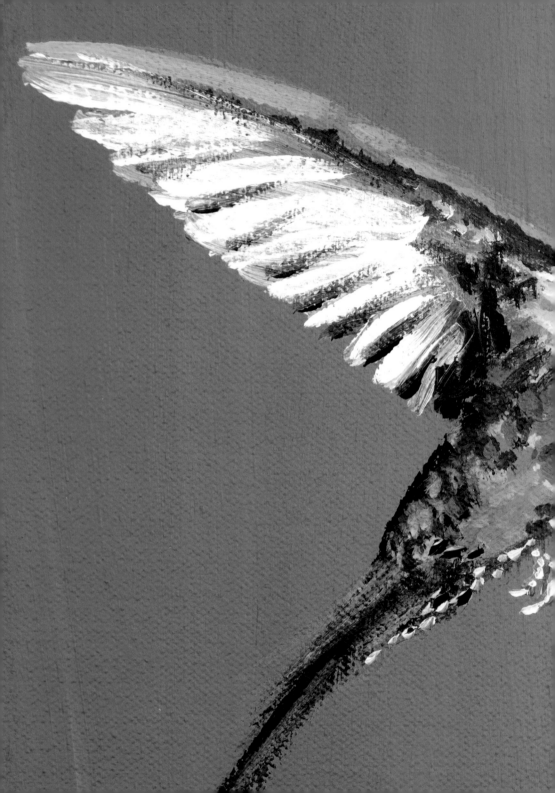

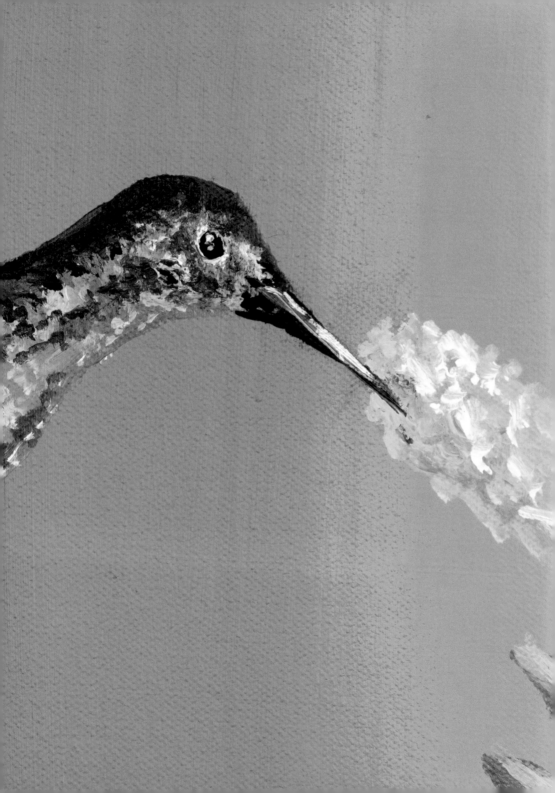

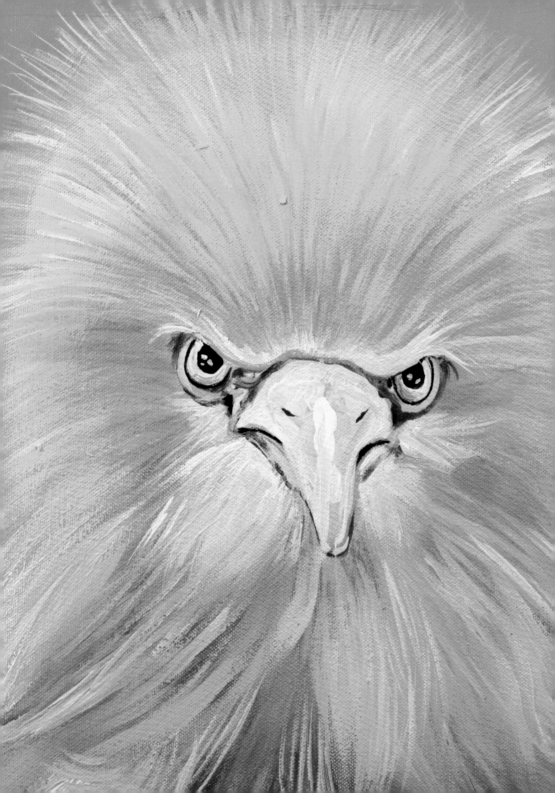

Giving The Bird

Bird Stories
BY
Ashley Longshore

RIZZOLI
UNIVERSE

I love "giving the bird"—I would like to dedicate this book to all of those with a sense of humor and a love for art. I try and laugh so hard I pee in my pants a li'l every day. I would like to give the finger to all the bitches and trolls who have been hateful and mean, and underestimated my tenacity to combat their bullshit with talent and a sense of humor.

I am writing this from a bubble bath in my studio at 2:30 p.m. on a Thursday. Suck it, haters.

Contents

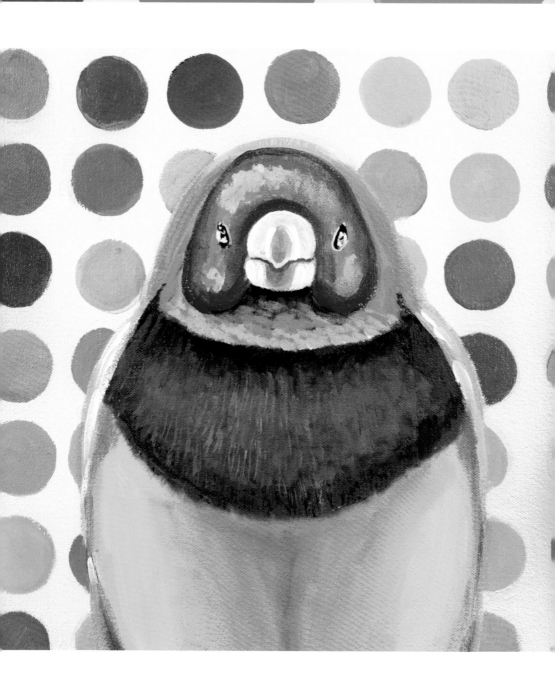

Todd

Toddalomius cuntymaximus

Meet Todd. He works in retail and sleeps in a nest above T. J. Maxx. He lives (and tweets) fashion and brags about his clothes, but we all know he is using that employee discount at Macy's. When whipping out his Discover card, his favorite expression is "like shit through a goose." He is a total size queen. He seems very sweet in person but is nasty in the nest. He won't let his lovers sleep over and he eats Krispy Kreme donuts during and after coitus. He went through a horrendous breakup with an ornery lil' twink and is feeling a little fluffy these days after a two-month carb bender. He recently started doing Zumba and the male version of Kegels. His drink of choice is a Cowboy Cocksucker: Baileys, whiskey, and whipped cream. After four of them he can karaoke a perfect version of "How Many Fucks" by Erika Jayne, with choreography. Todd is approachable, but is known for extreme bouts of sarcasm. Be prepared for Joan Rivers–type heckling and label-whoring. Overall, he is a magnificent, very entertaining bird. He is best for brunching and for having the best GIFs ever.

Mrs. Gooch

Goochy paranoius

Meet Mrs. Gooch. Her nest smells like Chanel No. 5 and mothballs. She claims to have eyes in the back of her head and sees and hears everything within a twenty-foot radius of her beak. She curses in her mind a lot but would NEVER use profanity in public. Mrs. Gooch did a lot of acid in the seventies and is a little paranoid. Her purse (a brandless fabric tote) makes a shaker noise because it's full of pills for high cholesterol, yellowing toenails, menopause, and "calm down" pills. She loves rocking Eileen Fisher tunics and Manolo Blahnik kitten heels. When she smiles, she always has lipstick on her teeth. She drives a Lincoln Town Car and can't parallel park worth a shit. Her grocery list consists of plums, Senokot, and kiwis. Mrs. Gooch has been suffering from constipation for years.

She recently had her bladder pinned up because she peed on herself a lil' every time she asked to speak to the manager. This bird is very high-strung and should be observed, not approached.

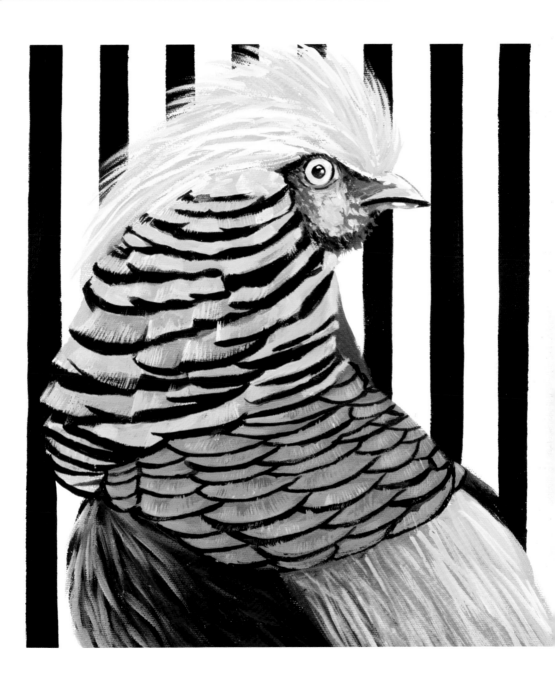

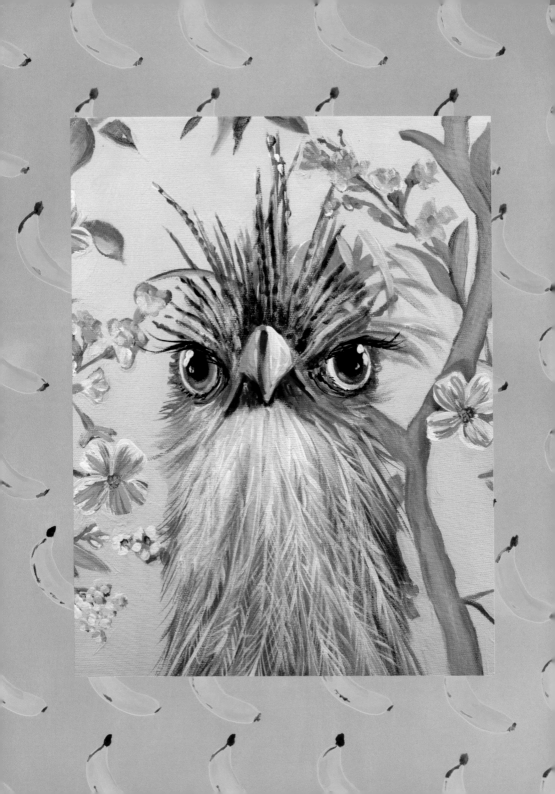

Sarah Jane

Sarahjanius fruitopius

Meet Sarah Jane. She is so rich that her nickname is Banana. She lives in a nest on the right side of the street in the right part of the city by the CUNTRY CLUB. She lunches every day with some mean old hens. Banana is the nicest one of the bunch, although she is obsessed with watching the food everyone eats and is an expert on what foods will bloat a chick. She is always pecking lint off the other gals' Chanel suits, and cackles when their Birkins aren't exotic. She stays in shape by doing Jazzercise every day at 7:30 a.m. after a black coffee and a bowel movement. You always know when Banana is tipsy because she blinks a lot and tosses around her feathers more than usual. She also gets white foam in the corners of her mouth when she drinks chardonnay. Banana has worn Jimmy Choo pumps for the last thirty years. She is an approachable bird but is not fully trustworthy; she is prone to malicious gossip. Proceed with caution. Only tell her what you want EVERYONE to know.

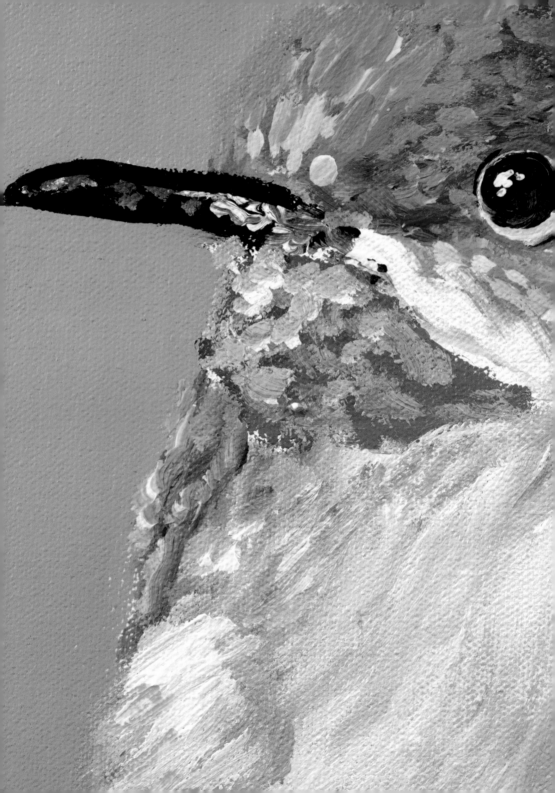

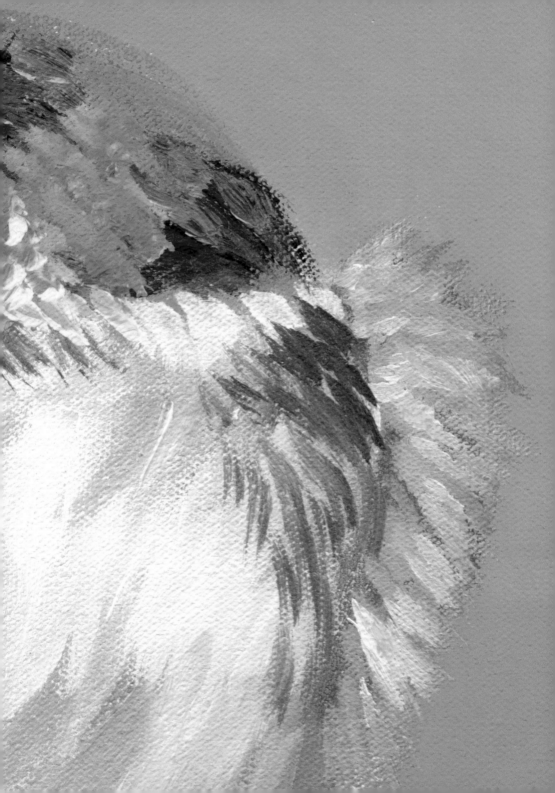

Looloo

Lawrenius alopecius

Meet Looloo. Her current mood: just chillin'
like a motherfucker . . .

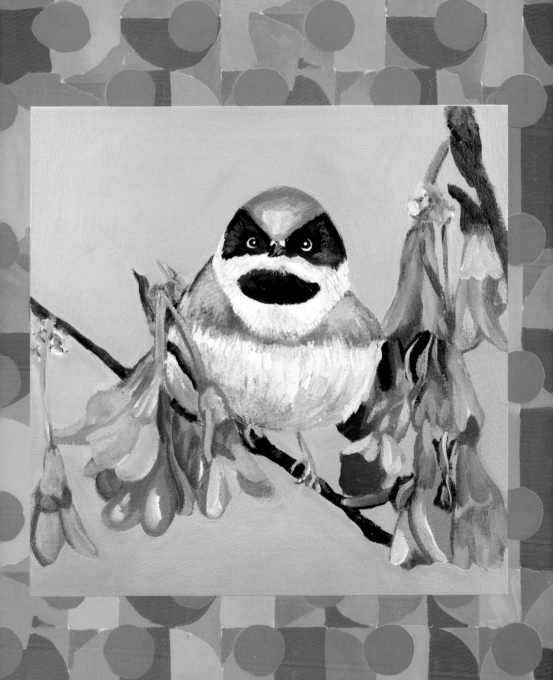

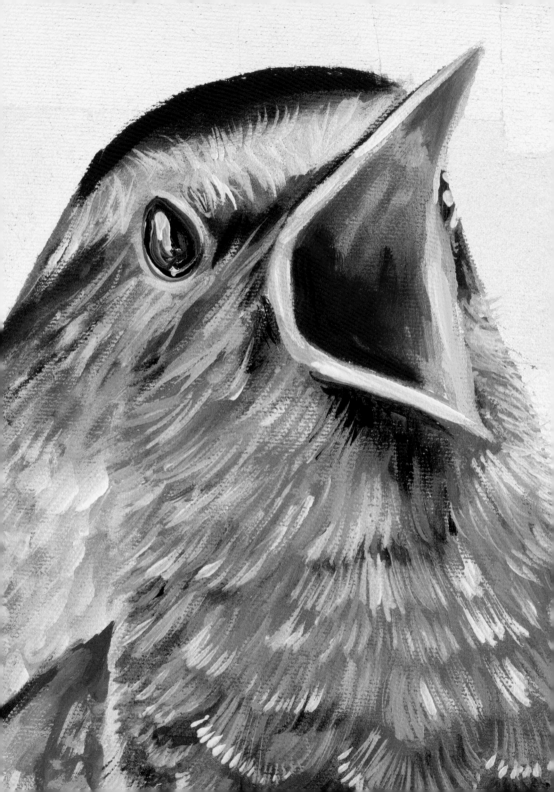

Vanessa

Vanessius yogamomius

Meet Vanessa. Her nest is bigger than yours. She already knows everyone you haven't met yet and has already eaten everywhere you haven't even thought of eating. She has already seen every fashion collection on the planet that hasn't even been created yet. She can do a twenty-four-hour exercise program in three hours. Her fifty-five-minute massage only takes ten minutes. She already knows all the words to Beyonce's next album that hasn't dropped yet. And she has already burned all the calories from the cookie she hasn't even stuffed in her beak. If you wear three-inch heels, she wears seven-inch heels. If you have one diamond, she has one hundred. If you have a Honda, she has a Rolls. If you have an orgasm, she has a billion. She has already been invited to every party on the planet that hasn't even been planned yet. Her species is the know-it-all. This bird is not dangerous but is incorrigible toward anyone who gets inside a ten-foot radius. Keep a safe distance and observe from afar.

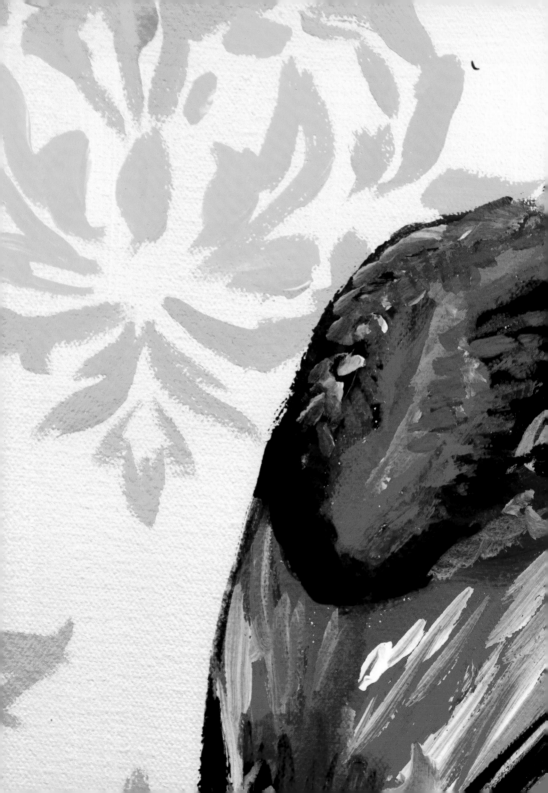

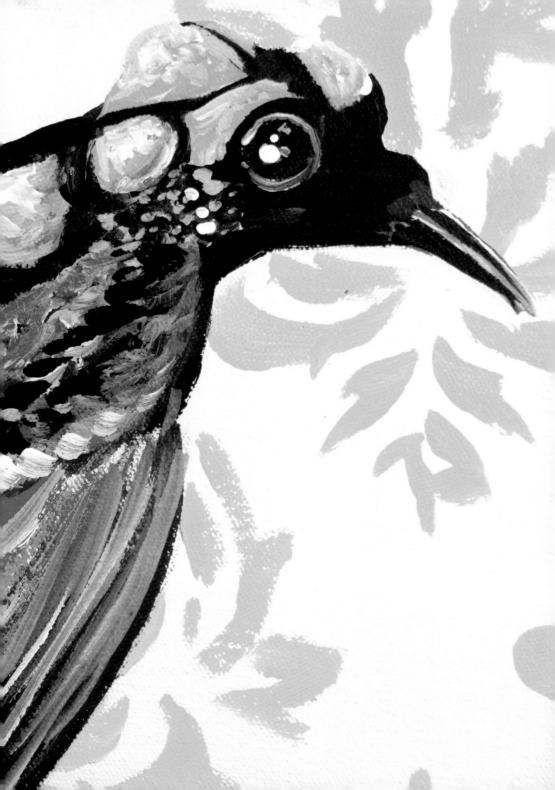

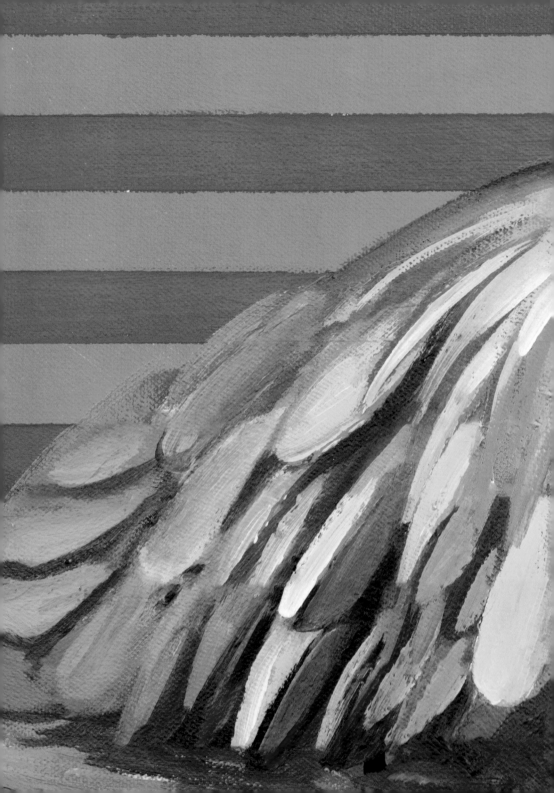

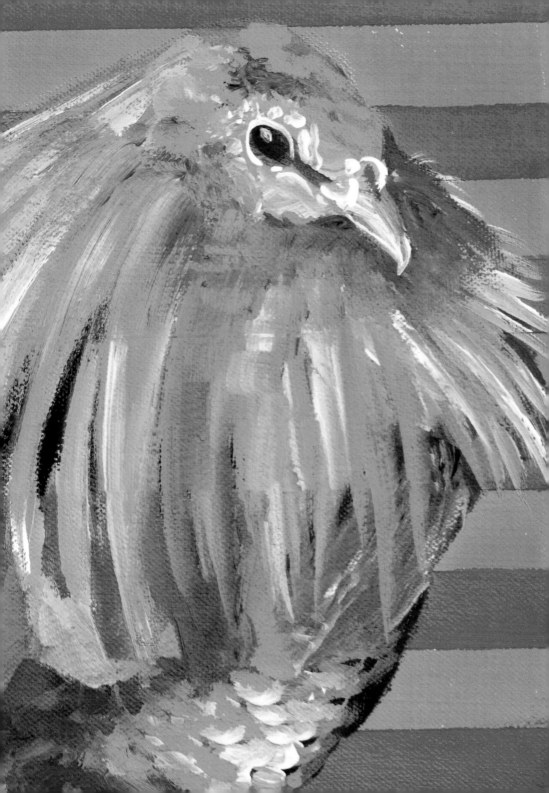

Tina

Tina whateverittakesimus

Meet Tina. Her friends call her Cricket
because she loves to wear pantyhose and
her thighs make a chirping noise when she
walks because they touch. She always wears
a Spanx tank top and is constantly on some
sort of scam diet. She drives around with
a cooler of Jell-O shots to pass out to her
friends and a box of dildos to place on the
windshield of cars that park too close to
her. She drives a pickup truck and has a side
business making silk floral arrangements.
Her greatest regret is the time she gave a
blow job for a Kate Spade bag in college.
You will rarely see her eating in public, but
late at night she eats pizza and spoonfuls
of peanut butter in her Spanx tank top and
granny panties by the light of the fridge.
This bird is not threatening at all and is
considered quite friendly.

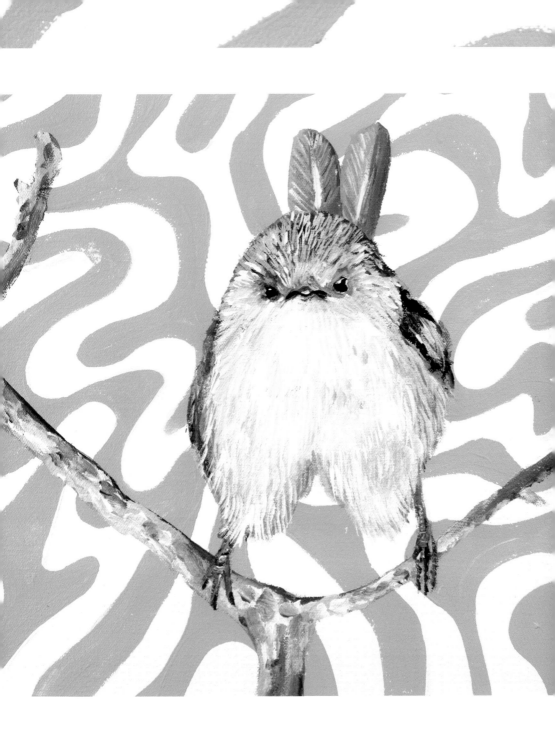

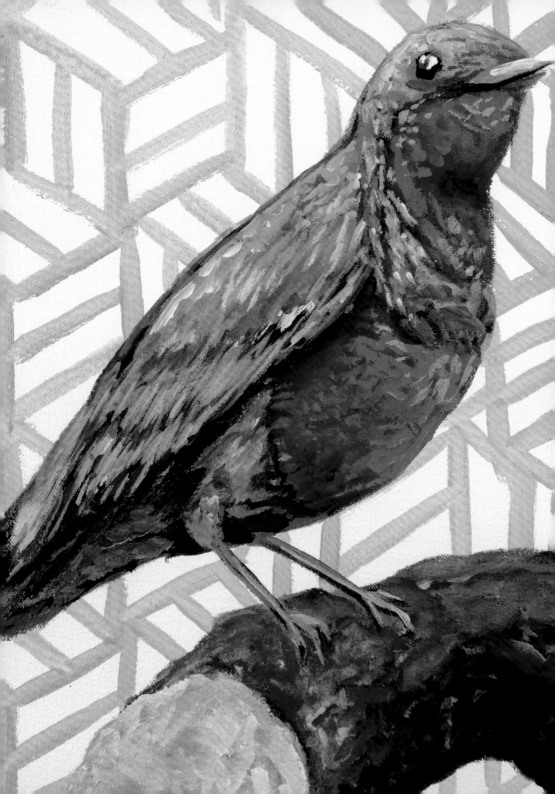

← *LEFT*

Horus

Horusmaximus slobonius

Meet Horus. He is the motherfuckin' banded cotinga. Horus is colorful and radiant but most definitely a stinker. He is known to be a couch cruiser; the cotinga will smoke all your weed and is a self-proclaimed beer snob. Horus is a complex creature. This bird is known to be a "chubby chaser," which means he likes fluffier birds in the sack. Favorite curse word: SHITBALLS. Favorite junk food: CHILI FRIES. Favorite sex position: JACKHAMMER. Favorite hobby: SHITTING ON LAMBOS.

NEXT PAGE →

Dana

Danarius hotmessimonius

Meet Dana. She currently nests above a salon that specializes in anal bleaching. She can lip-sync "Genie in a Bottle" perfectly and, when intoxicated, performs the Footloose dance flawlessly. Her guilty pleasures are donut holes and bowls of Cap'n Crunch, and yes, she is one of those nasty bitches who drinks the milk. Not commonly known: she is a nervous bird. She spends much of her time seriously constipated because she thinks the other birds are talking about her. The irony is that she pees on herself every time she sneezes. Her song of the summer is "Swish Swish," but she likes to fuck to "Despacito." Her favorite cocktail is a nice big glass of Shut the Fuck Up, and her drug of choice is Ambien. This bird should be approached with caution. Although seemingly harmless, her passive-aggressive tendencies can be dangerous.

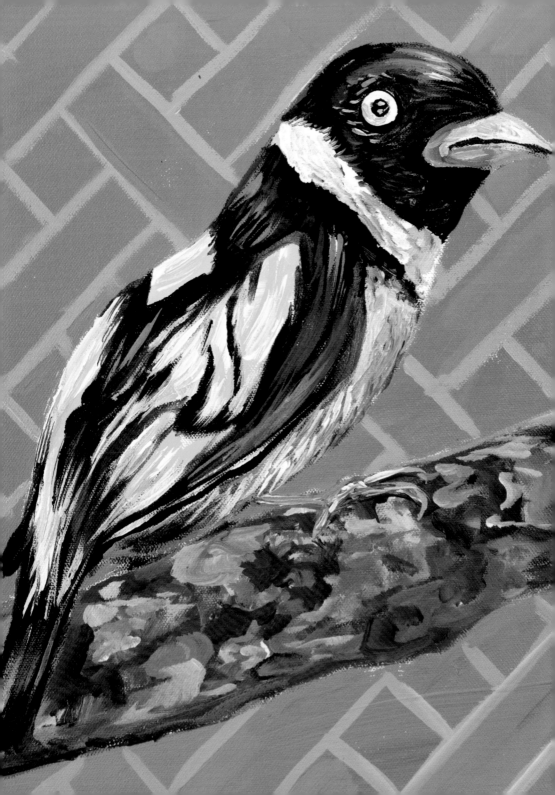

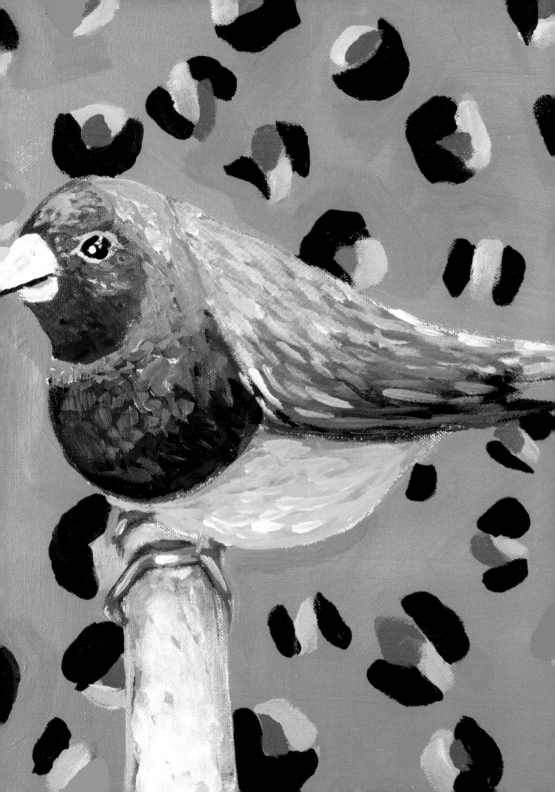

← *PREVIOUS PAGE*

Mary Kate

Marykate winovius

Meet Mary Kate. Her tennis group calls her the Kegel 'cause she needs to loosen up. She is beautiful, NO DOUBT. She is the kind of bird that gets naked at the gym just to show off in front of the other birds. She always lotions up her legs before she flies out of the house and she never leaves the nest without cleaning her diamonds. She can drink gallons of chardonnay and always has a stash of Ritalin and Xanax. She listens to Sam Smith super loud and only flies around high-end shopping malls. She is passive-aggressive as fuck and whines about her nanny to the other birds. Her man has been fucking a yellow finch for years, but she can't leave him, or he will take her credit cards. She doesn't like to eat in public because she's trying to lose three pounds. She is a VERY beautiful bird, but beware. She can attack unexpectedly and completely unprovoked. Admire from afar.

RIGHT →

Penelope

Penelopus gluttonius

Meet Penelope (pronounced Penny-Lope). She ain't on Ozempic and has no interest in being traditionally thin. She lives in a nest made of M&M's wrappers and Chanel tissue paper directly above the outdoor restaurant of a luxury vacation resort. She has an insatiable appetite for carb acquisition and an aerodynamic body built for snack zoomies. She is famous in bird hotel circles for her dramatic carb plunge: the Fluff Swoop. She snatches pastries from tourists with enviable precision; the other birds get peanut butter and JEALOUS! She got into a fight over a croissant with a super bitchy blue jay named Tay Tay. After the nasty tussle, Penelope is missing two toes on her left foot and she kinda hops with a nasty, sassy little swagger because of it. She breathes really heavy when she flies, except for her carb dives. Inertia is her natural gift. She loves her girth, her fluff, and her natural, grand presence. She loves singing "Players" by Coi Leray LOUD in front of the male sparrows that make fun of her fluff. In the off season, she loves making TikTok videos about UFO conspiracies, taking Vyvanse, and baking banana "Gimme That Nut" bread. Penelope looks pretty harmless but do not make eye contact or approach casually. Share your bread basket, and there should be very few issues.

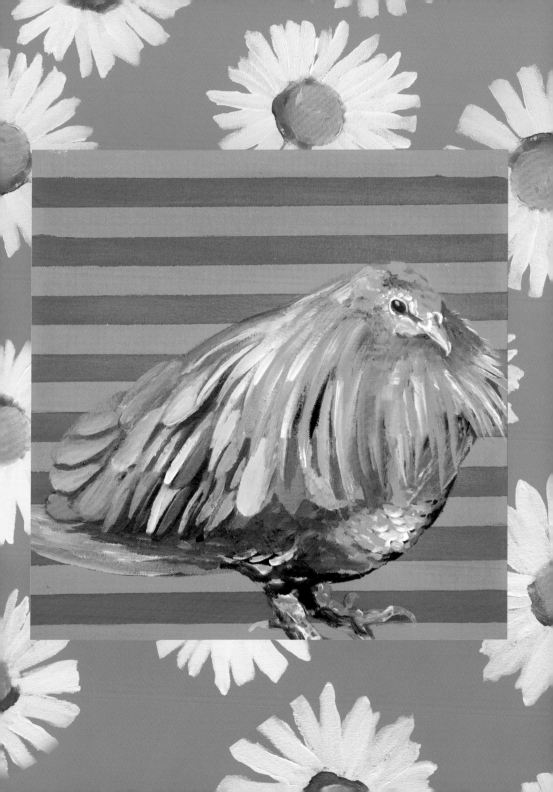

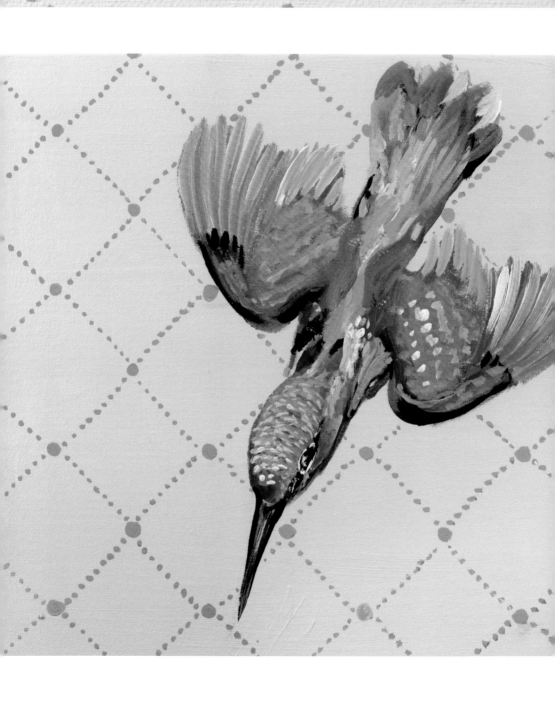

Zach

Zachariahus maximus

Meet Zach. Daaaaammmmmn. OK THEN, ZACH! Aggro but sexy! This kingfisher is a BOSS and he's comin' in HOT. You gotta GO FOR IT . . . get that paper, get that chicken nugget, get that BREAD. FOCUSED. Boom.

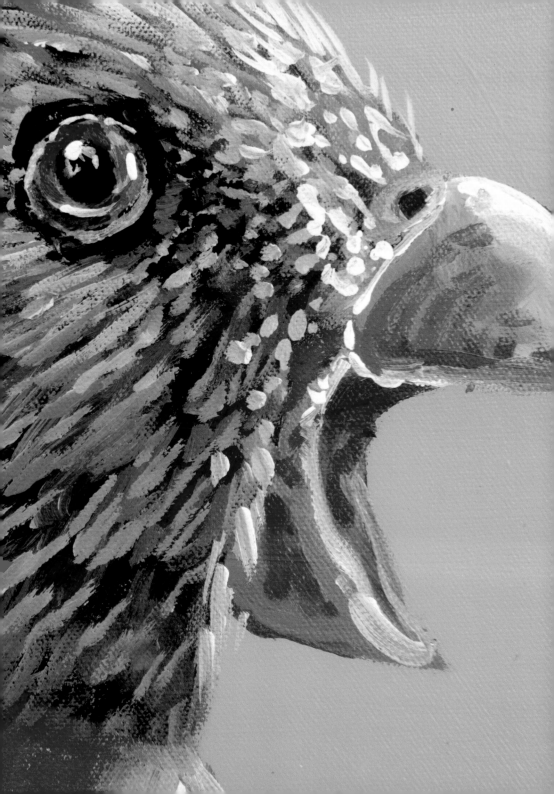

Connor

Connoralus spectaculimus

Meet Connor. He is so EXTRA—extra
GORGEOUS! He's a dwarf kingfisher. Does
he know how spectacular he is? Does he
sing a little louder because he is so colorful?!

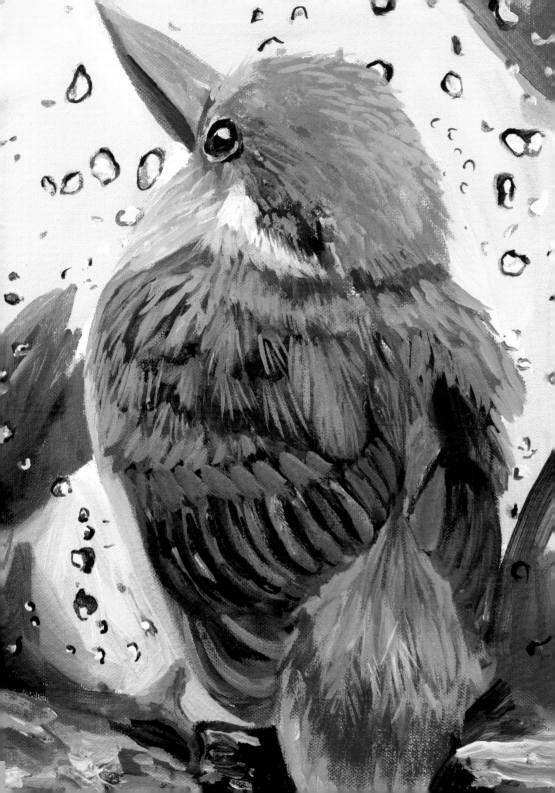

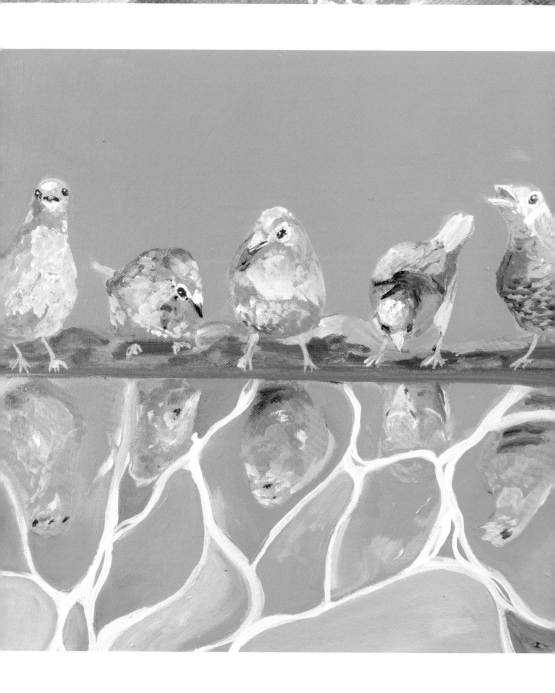

The Plastics

Plasticinus narcissistinus

Meet The Plastics: there's Cady, Regina, Gretchen, Karen, and Ms. Norbury. These birds are going through a morning ritual anyone should do: staring at their reflection thinking "I would fuck me so hard." Then they go fly around doing boss bird stuff, like singing as loud as they can from the top branch of the tallest tree and fluffing their wings in a giant puddle. It's textbook badass bird stuff. Love them!

Rebecca

Rebeccalonius wreckingballius

Meet Rebecca. She lives in a nest by an Anytime Fitness, and she thinks leggings are pants. She has never been to the Anytime Fitness, but she watches the commercials religiously. Rebecca's nickname is Wrecking Ball. Rebecca likes frozen margaritas and Bagel Bites. She has one star on her Uber rating because she pukes and fucks in the cars—not in that order. Rebecca has never had a bikini wax and sports major side bush by the pool. That's why her friends call her Wrecking Ball: she kills them every time. She likes guys who wear denim shorts and shave all their body hair. After five drinks and the right lighting, she looks like a dove. Rebecca is NOT a threatening bird unless she has had tequila—in which case, approach slowly and do not make direct eye contact.

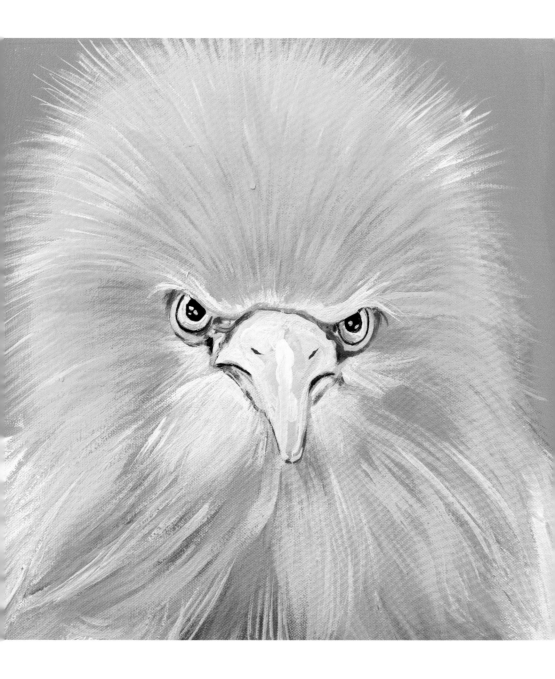

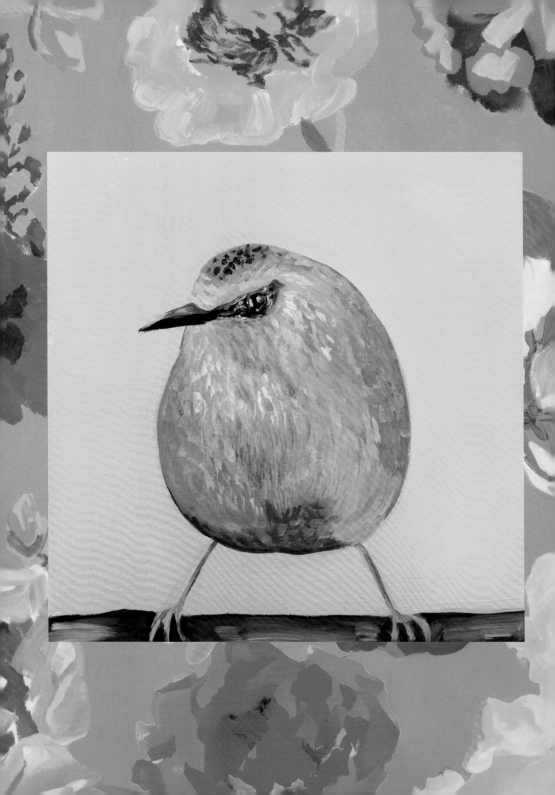

Martha

Marthamaximus disorderus

This is Martha. Unfortunately, Martha
had an adverse reaction to her Ozempic.
She is starving and bloated and has been
constipated for four days. She is brewing up
an epic fart that will surely rattle the forest.

Babs

Barbarius pretentalonius

Meet Babs. Aka Barbara, aka the Iron Puss, aka the Ball Buster, aka the Biggest Bitch in Town, Babs makes being pretentious a sport. She goes to EVERYTHING she's invited to. She would go to the opening of an envelope. She is the meanest bird on the block. Every morning after her laxative kicks in, she chugs a glass of room-temperature prune juice. Then she does Pilates and pelvic floor exercises in a T-shirt that reads "Judging You." She wears a camel toe cup under her Prana leggings because she was body-shamed by the president of the Junior League. She has a string of emasculated ex-husbands and is currently engaged to a gay man. Babs lives in a nest in the most expensive neighborhood and has a sterling silver keychain flaunting her zip code. She can drink gallons of chardonnay unphased and has a secret cigarette habit. Her email sig line reads "Happiness is Expensive." Babs may have had many husbands, but she has never had an orgasm. Avoid Babs but stay on her good side! Babs is dangerous, pretentious, and mean as a snake.

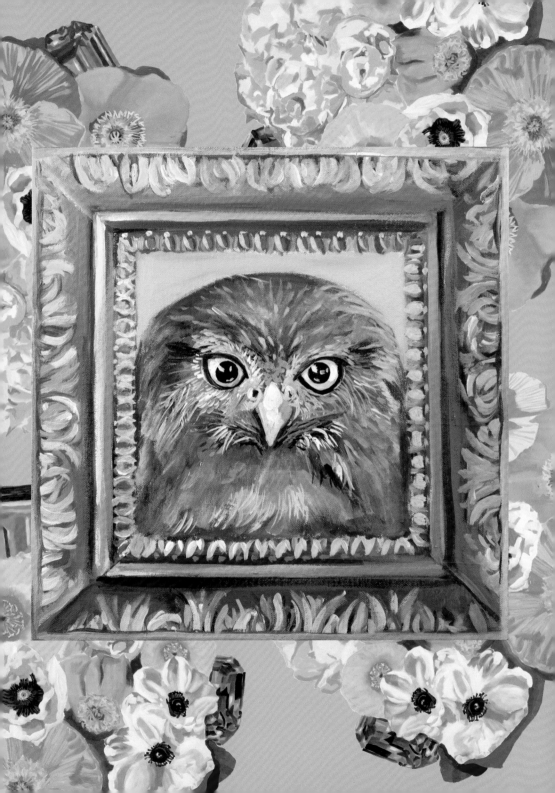

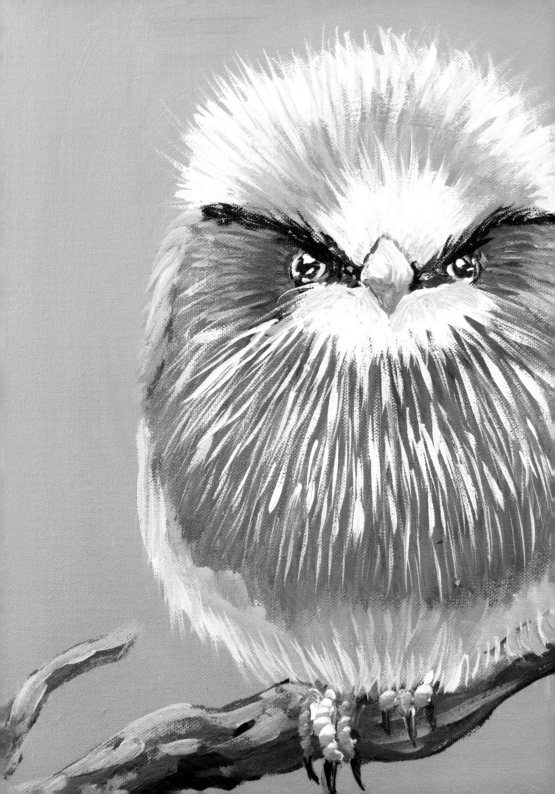

Rupert

Rupertonius twinklepantsimus

Meet Rupert. Rupert is a motherfuckin' lilac breasted fuckin' roller y'all. He lives off of cold pizza and hot diet Sprite and goes cray cray when Ariana Grande's "7 Rings" comes on. The last book he read was *The Woman in Me*. His favorite restaurant is Cipriani Downtown. He can't live without Skims tank tops. His favorite curse word is cocksucker, and his life's motto is "If you can't join 'em, shit on 'em."

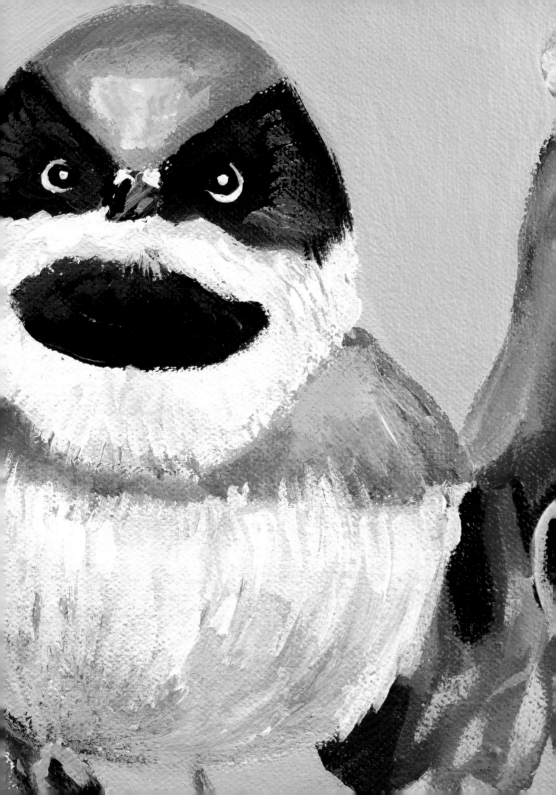

Tabitha

Tabithonius pinkystinker

Meet Tabitha. She lives in a nest of shredded Charmin above a self-help clinic. She's mean as a snake and is nicknamed the Judgeopotamus. She attends everything she's invited to, hence she'd go to the opening of an envelope. She watches what everyone eats and makes lil' pig noises under her breath when she sees women eating carbs. Tabitha's entire anus and genital area have been clenched shut for years; she is a human Kegel. The last time someone went down her pants—after a glass and a half of rosé—she told them, "Only a pinky to the first knuckle. I'm a lady." She thinks masturbating is a way to catch bigger fish. She has a bumper sticker on her Honda Civic that reads "Only Jesus and Me Can Judge You." In college, she went to eat ice cream and left without paying and coined it the lick-and-leave. Ironically, this is also how she refers to her first two divorces. Tabitha hasn't had a carb in fifteen years nor a solid stool. Her nickname at work is Potty Painter. Tabitha is flammable. She reeks of Shalimar and Aqua Net. She has never owned a pair of jeans and refuses to wear athletic wear. She LIVES for luncheons. She always judges the ink and handwriting on peoples stationary and is HIGHLY offended by profanity. She has never opened her eyes during sex and thinks anal is not an option, but a way of life in the bedroom. She cannot handle spicy food and is convinced curry causes "anal leakage." Tabitha has been cursed with bad allergies and pees a bit every time she sneezes. Her style icon is Mrs. Doubtfire. Her checkbook is perfectly balanced, and her last purchase was stool-hardener. She is a very volatile bird and should be approached with great caution. She will peck your eyes out.

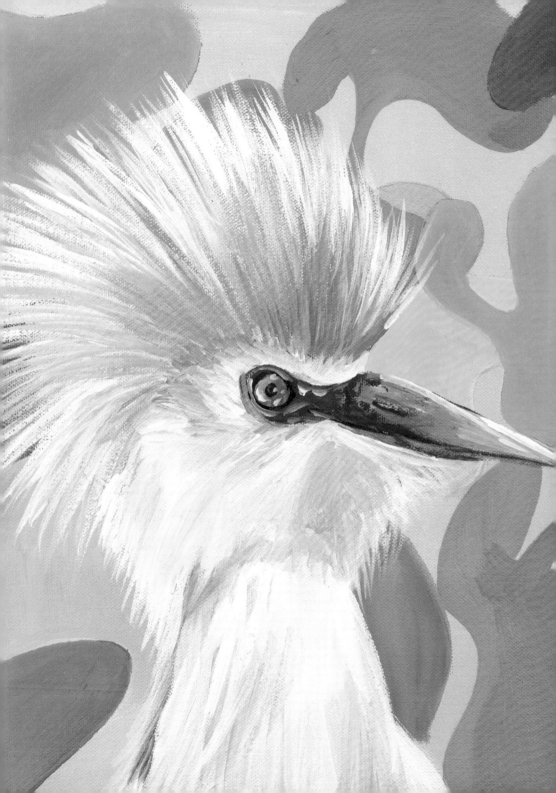

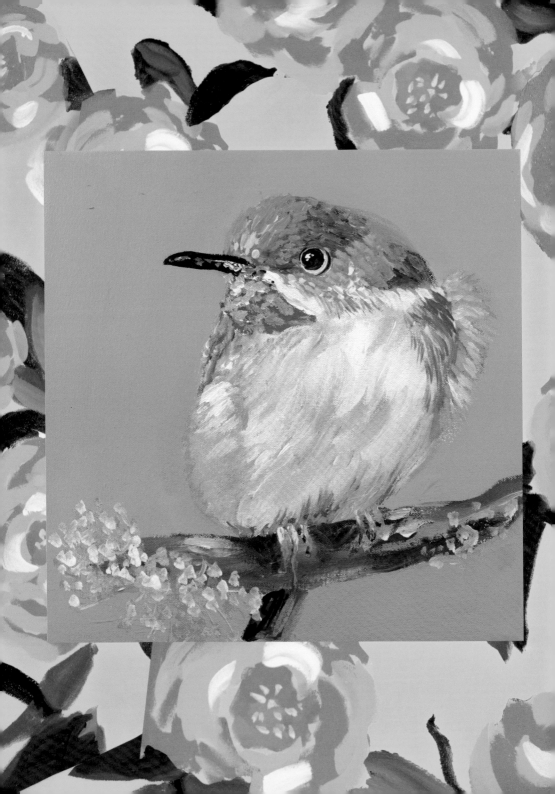

Muffykins

Muffykinsalus cameltorius

Meet Muffykins. Muffykins lives in a nest of shredded parking tickets above a spa for vagina steaming. She drives a Range Rover and listens to "Firework" by Katy Perry every day on the way to her barre class. Muffykins can sing, talk on the phone, take a selfie, and drive the car all at once. She also does cardio in contouring makeup and four-inch hoops. Once she thought she got a sign from God in a spin class because there was a sweat mark on her Lululemons in the shape of Jesus, so now she does spin religiously. She tells her friends "Jesus doesn't want my thighs to touch." Muffykins likes to wear Gucci, but her dad cut off her trust fund because she dated a broke poet who is famous for having three gonads. Her family nicknamed him the Sperminator. Muffykins takes Xanax with her coffee and likes to vacuum the carpet until the vacuum tracks line up perfectly. Since her daddy cut her off, she wears athleisure a lot. She has perfected the "joe-n-toe": when you troll for ass at Starbucks with a camel toe. Muffykins gets a little crazy when she drinks. She gets sassy with waitstaff, and calls people "hun." She thinks bread baskets are possessed by the devil and has a problem with caressing busboys at restaurants; she calls them all "Glen Coco." Muffykins shoots tequila and then she clenches a lime and puts her whole fist in her mouth, and she says that's how you get "a real man." Muffykins is harmless and easily approachable. She is often passive-aggressive but not in the super-scary, psycho bitch way.

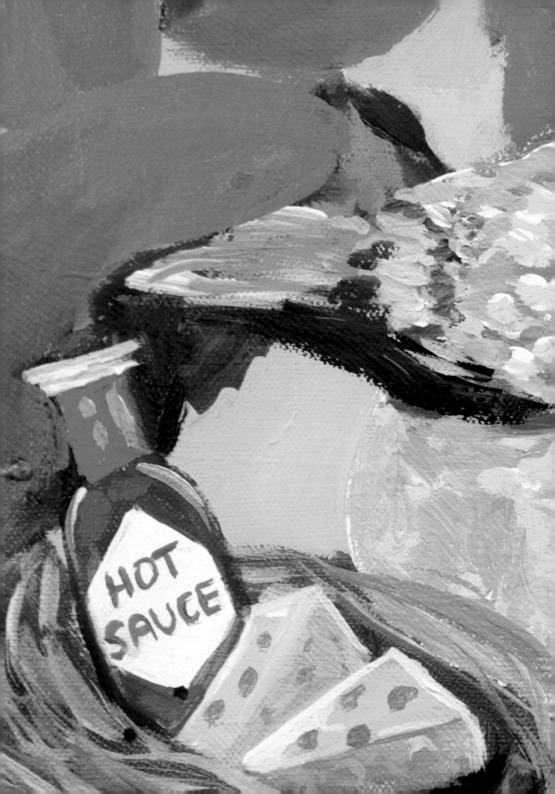

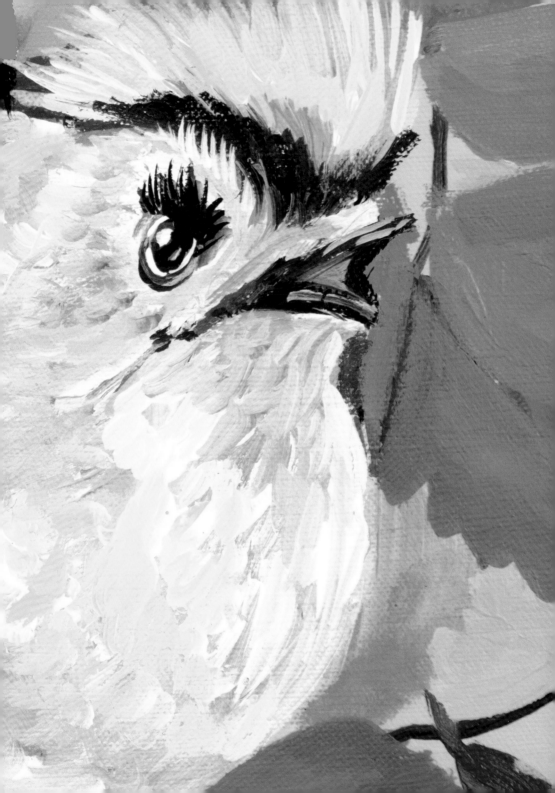

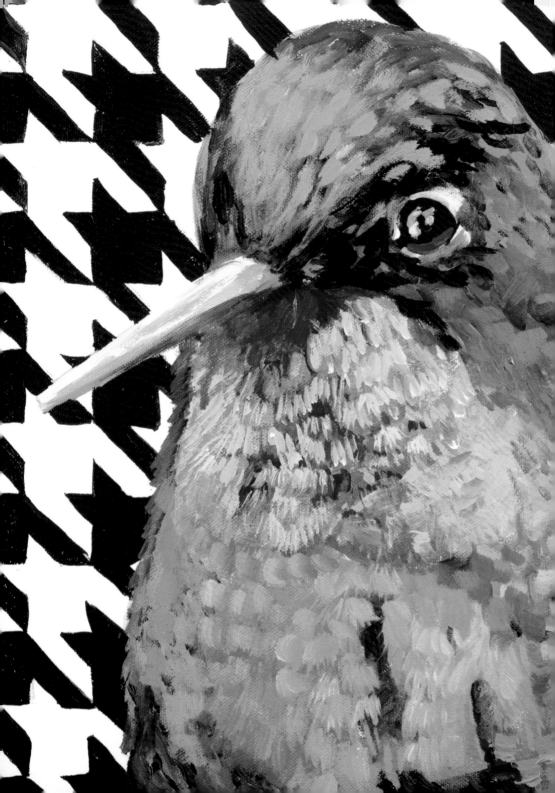

← LEFT

Chad

Chadalonius jazzonius

Meet Chad. He makes this face when he buys glitter, also when there are tacos or a martini, also when a package comes from Gucci, and also when the vibrator setting is accidentally on high. Love ya.

NEXT PAGE →

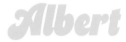

Albert

Albertius canikickitorius

Meet Albert. He's a fucking splendid fairy wren. This bitch lives in Australia. Albert is a fucking colorful badass and he takes no shit. His favorite band is A Tribe Called Quest and he prefers a spliff over the bong. He is VIP-listed at all the best clubs. He gets a lot of bird pussy. He is known for texting lady birds pictures of his junk late night and he has an Android because the bird porn is better.

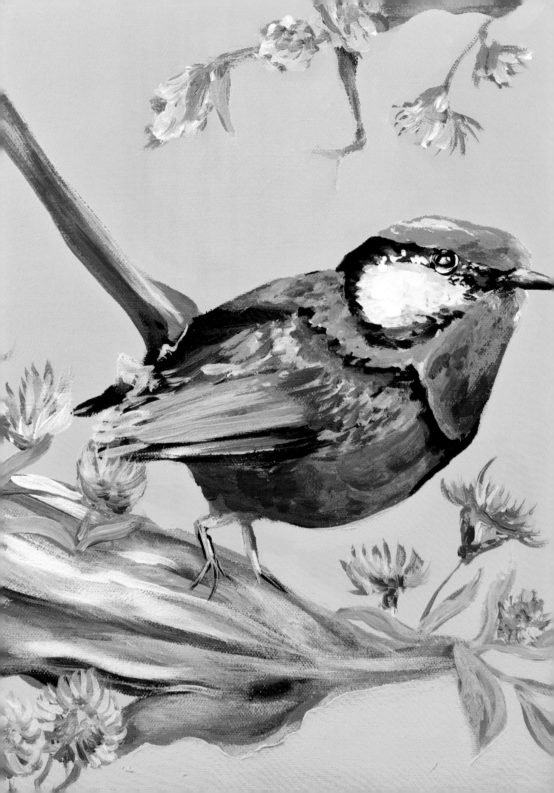

← PREVIOUS PAGE

Ricky

Rickymaximus longschlongorius

Meet Ricky. He is also known as the Nine-Inch Surprise. This hummingbird is a bad motherfucker. Sporting a rainbow mohawk isn't for everyone; but he has one, and he OWNS IT! This guy loves blasting Creed at red lights, Coors in the can, patriotic bikinis, and four-wheeling on the beach. He wears flip-flops to concerts and has great luck scoring pussy at the local Applebee's happy hour.

RIGHT →

Alistair

Alistairius alpha

Meet Alistair. He's a boss! When he is not flying, he drives a Bentley. And he gets all the bird pussy he can handle. His nest is in the VERY top of a mango tree, and word on the street is that he LOVES to go "downtown." IYKYK. He is living up to his maximum bird potential.

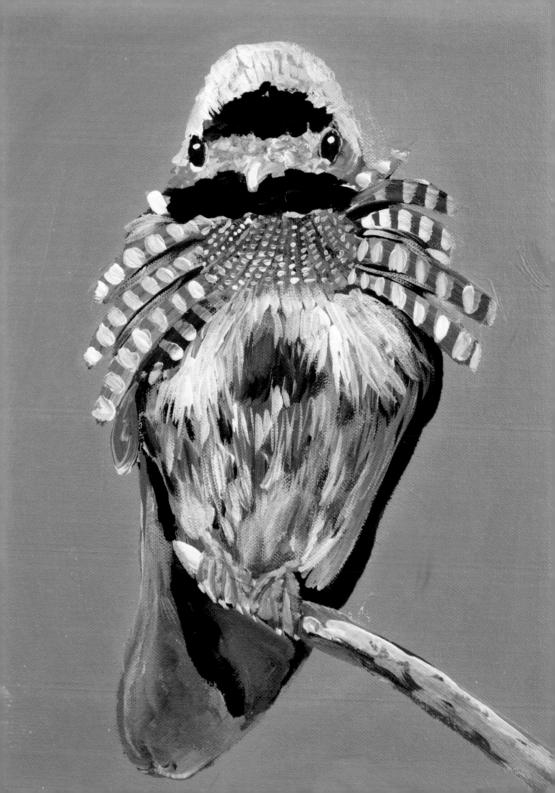

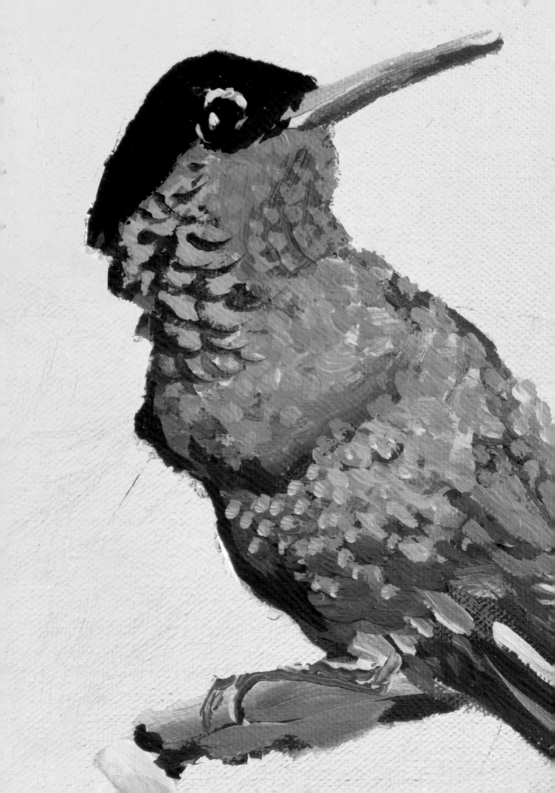

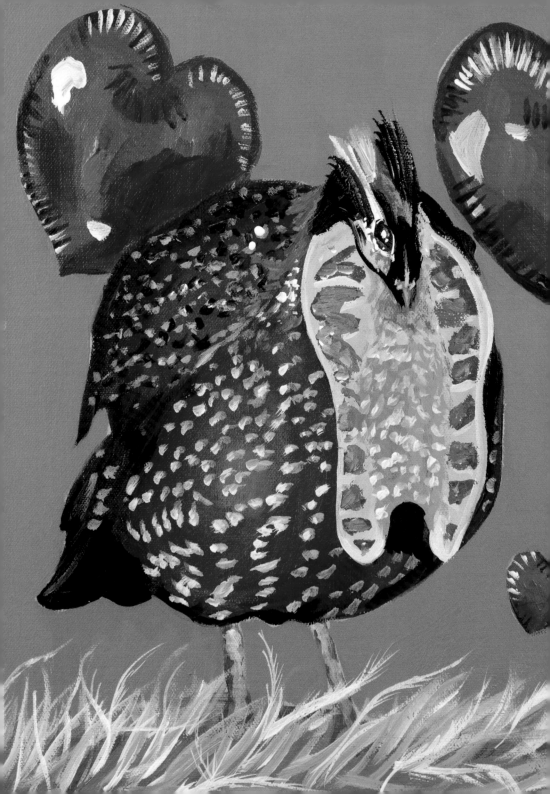

Emperor

Emperoris shagmaximus

Look at this magnificent creature—the original inspiration for the bikini wax. They call him Emperor, but he's also known as the horny pheasant because he has two li'l feathery horns on his head that get ERECT when he gets excited. Love him and how crazy colorful and horny he is. He gets more bird muff than you could shake a stick at. Slow clap for this guy.

Kyle

Kyleonius fembotorius

Meet Kyle. Kyle is a European turtledove and he don't give a fuck. He does what he wants when he wants to. He is smaller than other doves, flies erratically, and makes a purring noise. He secretly attends Adele concerts, watches *The Oprah Winfrey Show* reruns, and loves an oaky chardonnay. Sometimes when his wife is gone, he puts on lipstick and likes to fly around in circles. He is magnificent; he is glorious; he is perfect.

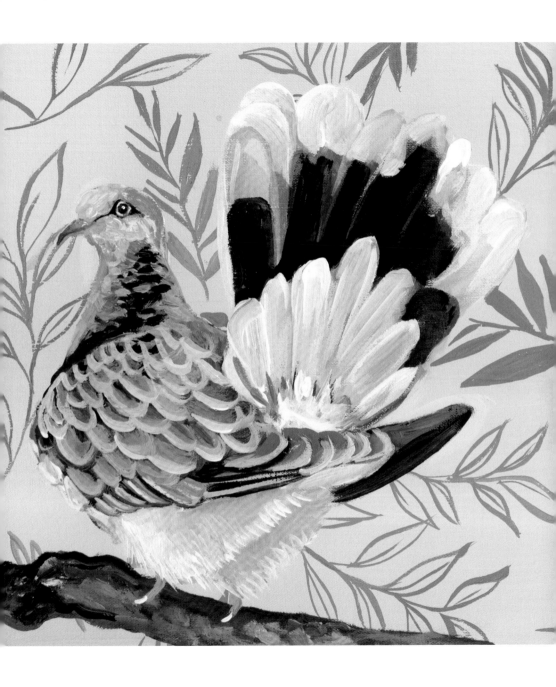

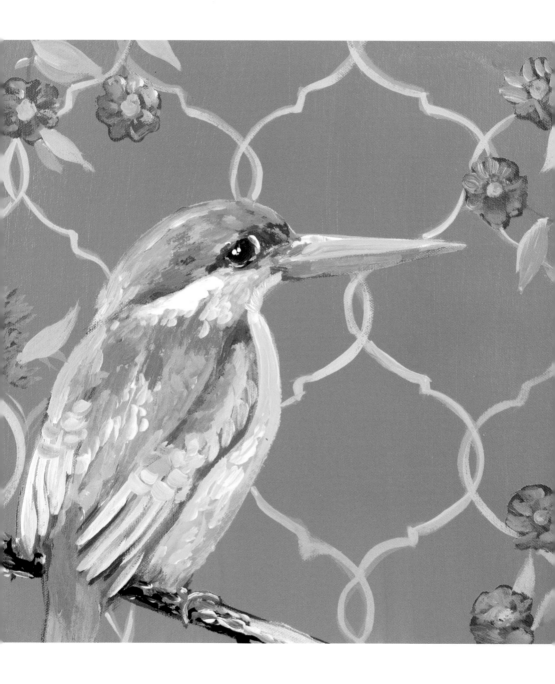

Harold

Harold dabossimus

Meet Harold. This guy, this guy right here, he is such a BOSS! And to think the other birdies made fun of him when he was younger. He was brighter than everyone else, and his beak was big and awkward. NOW he is magnificent and glorious, and the other camouflaged birds wish they were him. Funny how that happens. Like Harold, be radiant, marvelous, exotic, unique. The weirdest, most awkward characteristic might be the BEST thing about you!

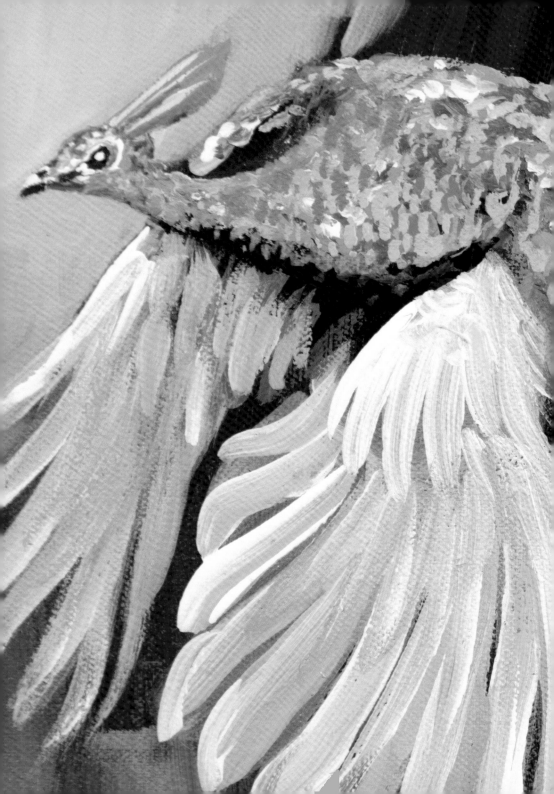

Fernando & Steve

Boyztown creampopmaximus

Meet Fernando and Steve. They live in a nest above a gay bar called OZ. They are fun as hell and throw the best parties. They have a closet full of housewarming gifts for their friends that range from Diptyque scented candles, Hermès ashtrays, and the best lube in the world that won't damage Frette linens. They have also been known to send a glitter bomb to uptight neighbors who don't approve of their colorful lifestyle. Steve is a partner in a law firm and wears a three-piece Tom Ford suit every day. He gets a boner every time he hears Josh Groban. He is in perfect shape and could crack a walnut with his ass cheeks. Fernando is a brilliant designer and has his own lifestyle brand called parTy and a bedazzled T-shirt company called Lil' Twink. He listens to old-school Madonna, Everything but the Girl, and Cher and could win an Olympic gold medal for his eye-rolling skills. He carries an orange Birkin full of tape measures, vodka shooters, and glow sticks. He pegs his jeans and shouts "coochie for Gucci" at Steve. Fernando and Steve are madly in love and are fun, spectacular birds. They love to dance and love it when the other lovebirds dance on top of the bar with their feathers plucked. They always carry tip money for these birds. They are 100 percent approachable unless you have a camel toe, a bad attitude, or a cheap handbag. Proceed with open arms and a smile. These birds are a favorite!

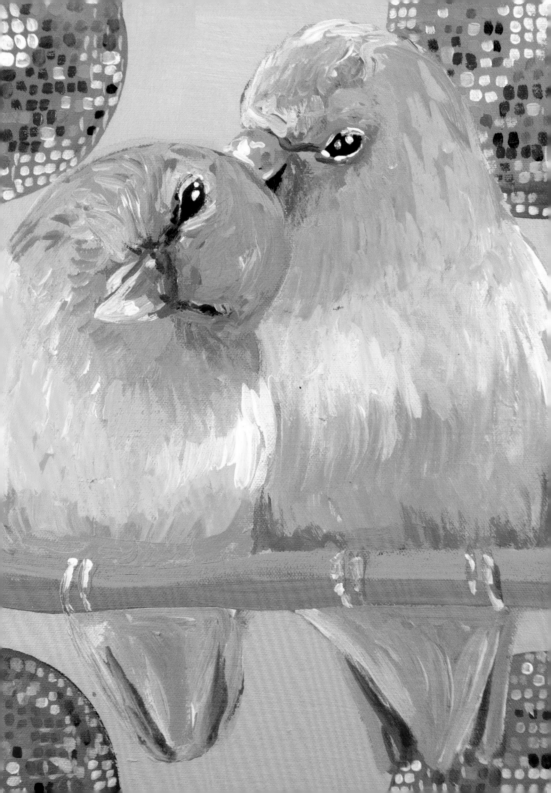

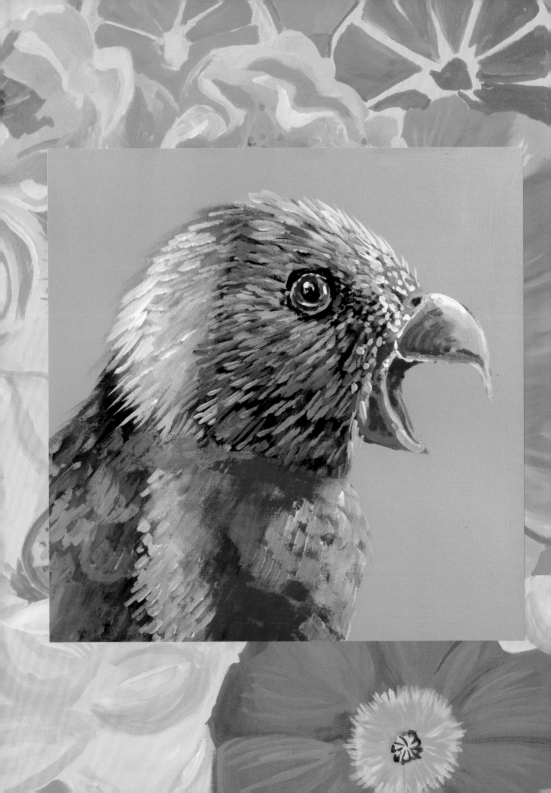

Benny

Bennyixus powerbottomaximus

Meet Benny. He is VERY proper. This is the
face he makes when someone crop dusts
the frozen foods aisle in the grocery store,
or in the security line at the airport, or in an
Uber, or in HIS bed. No, but really. This is the
coconut lorikeet from Australia! Ain't he
a stinker?!

Susan

Suzielonius spicyshitsimus

Meet Susan. She's a Taiwan flamecrest, but her friends call her Showtime. She loves to listen to Avril Lavigne really loudly and fly around abandoned Walmarts. She lives in a pecan tree outside of a P. F. Chang's and dive bombs women wearing Alo. Her favorite late-night snack is a block of cheese and shots of hot sauce. Her favorite TV show is *American Ninja Warrior*, and she likes it when people fall off the obstacle course. She prefers the "May I Speak to the Manager" hairdo because it "gets more respect." She drives a Toyota RAV4 and listens to anger management podcasts. Beware of this bird.

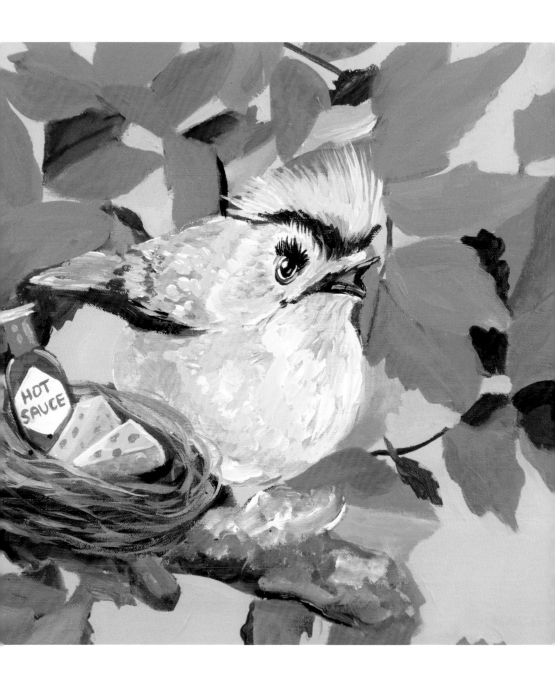

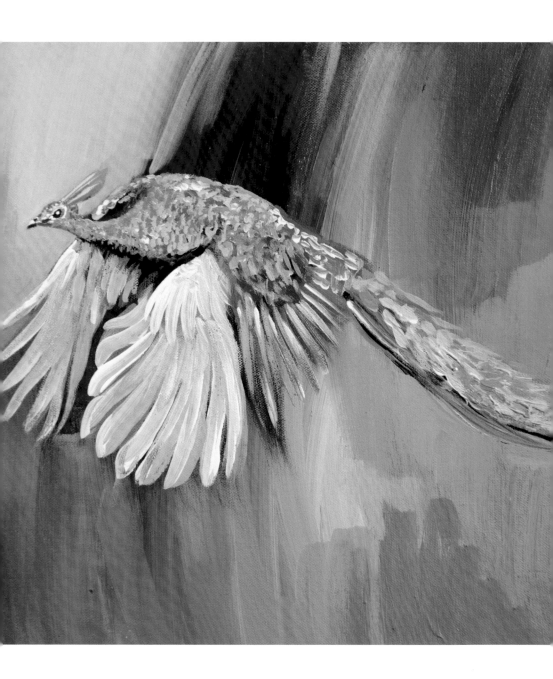

Cockzilla

Peacockilus zentorius

A flying peacock might be the most
dramatic, gorgeous sight ever seen. Who
doesn't love a giant flying cock? This is
Cockzilla, aka the BIG Z. He eats bananas,
hotdogs, and ass. Do not approach flippantly.

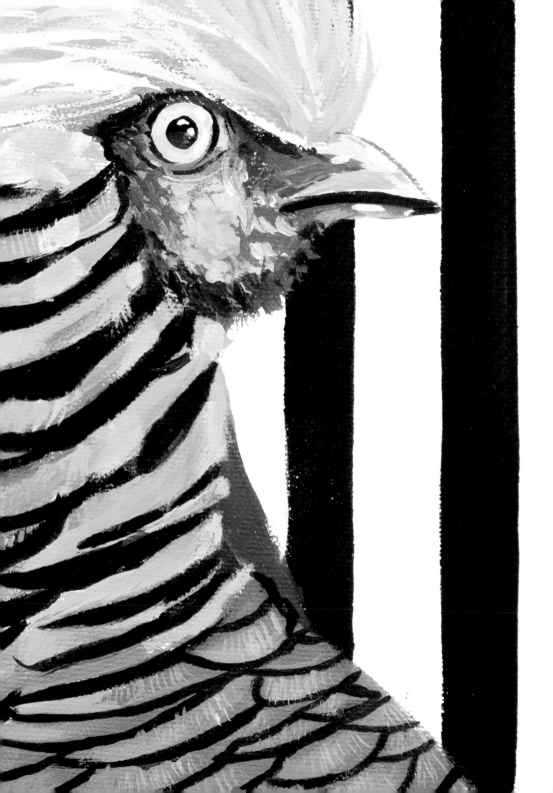

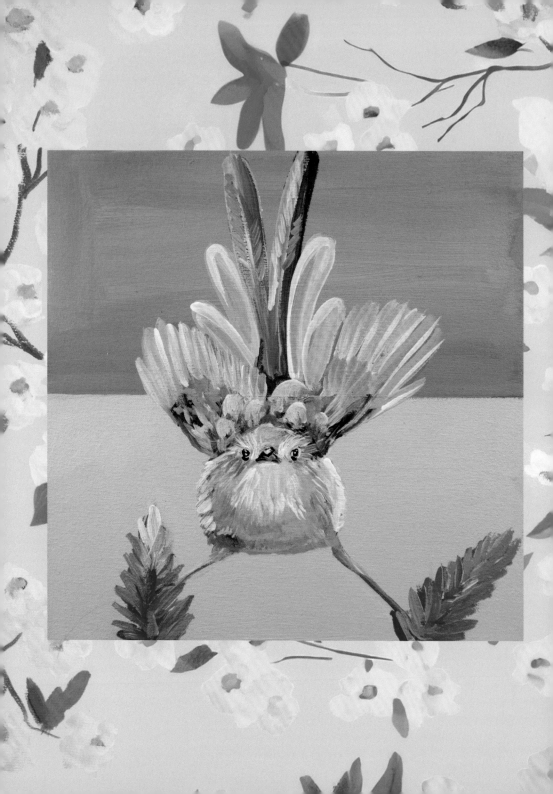

Becky

Beckylonius caloriecountera

Meet Becky. She lives in a nest above a weight loss clinic. She didn't gain one pound during the holidays because all she ate was salad with apple cider vinaigrette, and dick. She speed walks every morning in a visor and Lululemon tennis skirt and ironically the only balls she slaps around are her husband's. The visor and skirt are also her errand look. Becky's favorite hobby is mowing people down with her cart in the cheese section of Whole Foods. She calls it "chubby chasing," and last week she accidentally ate a carrot and speed walked for two hours in the mall before the shops opened. She wears a T-shirt to bed that reads "Is Dick a Carb?" Becky smells like sunblock and scented tampons. She is relatively harmless but considered aggressive. Admire from afar, especially when she is wearing her visor.

Lucy
Lucytorius lulu

Meet Lucy. Aka Lucifer, she goes by Lulu;
also mfw at a restaurant and need a fucking
martini and am making eye contact with
the waiter, but they ain't comin' over...

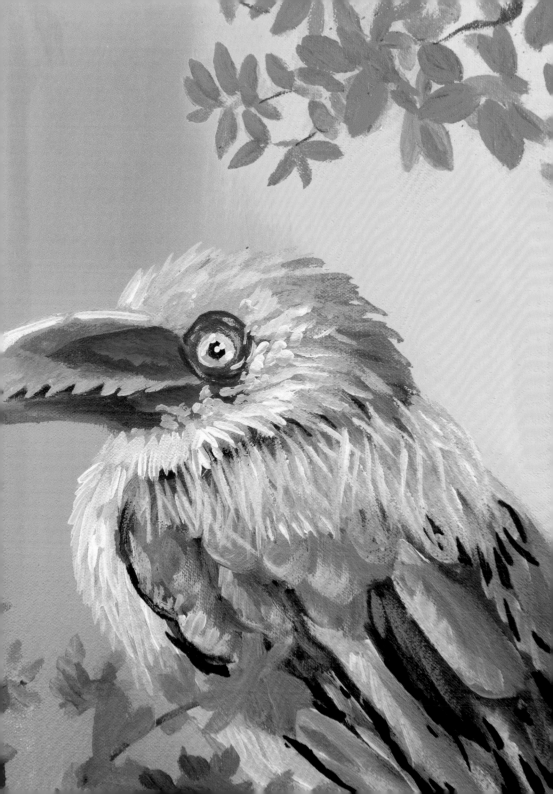

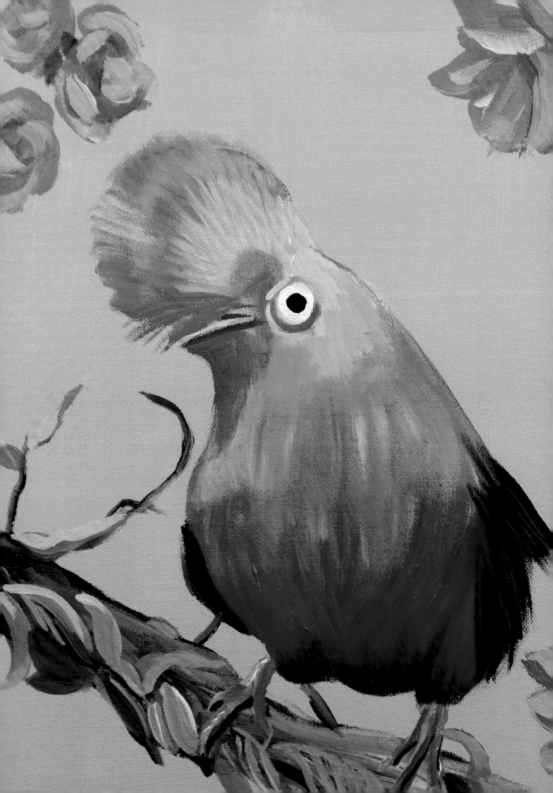

Dan

Daniel midwestcockzorius

Meet Dan. The "cock of the rock," he is magnificent and has a very elaborate mating display. He eats barbeque wings, chugs Miller Lite, and belches the alphabet. He likes to spit fruit and stuff at the gal birds. He is practically invisible in the rainforest except for when he is horny as fuck. He is into Led Zeppelin, taco trucks, shots of Sour Apple Pucker, and anal.

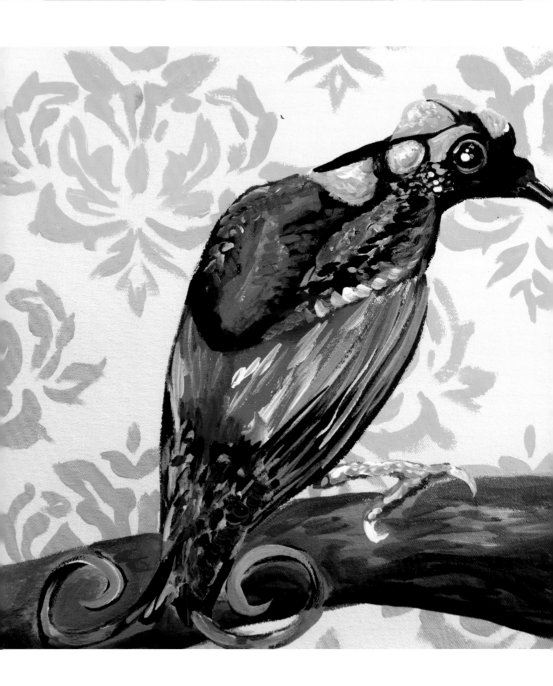

Nelly

Nellyzonius complusivarius

Whooooa NELLY! Check out this colorful creature! This is the Wilson's bird-of-paradise. He lives in Papua. He has fucking OCD. The first footage of him was taken in 1996, by dropping leaves in his pristine dirt ground space; that pissed him off and he cleaned the leaves immediately. The only way the females will mate with him is if he is perfect. Nelly keeps his shit CLEAN and tidy!

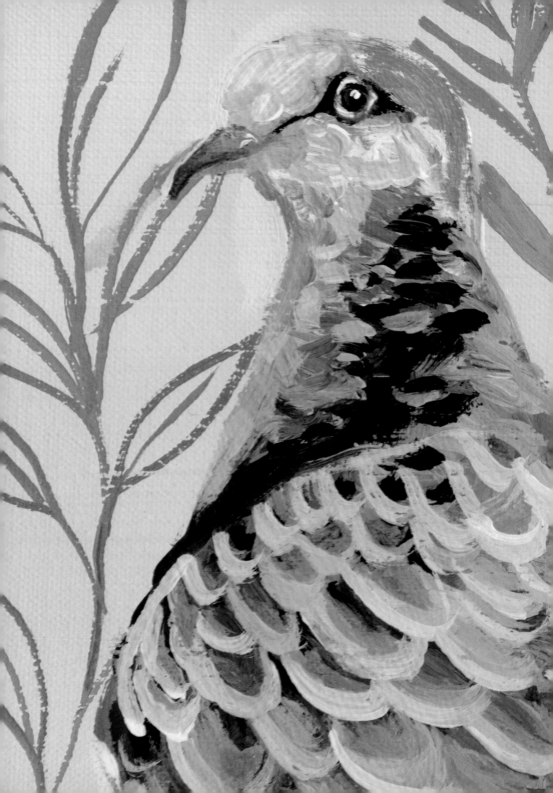

Mary Francis

Maryfrancis adderallius

Meet Mary Francis. She lives in a nest between an Orangetheory and a green juice bar. She hasn't eaten a carb in two years and has had self-inflicted diarrhea for six months. She is the prettiest, richest bird you will ever meet but she is crazier than a shithouse rat. She is the chair of the big "help-us-help-you" organization for the Junior League this year and is currently putting her husband in debt redoing the kitchen, powder room, dining room, and living room for the event. She secretly could give a rat's ass about philanthropic work, but loves any opportunity to show off all her shit and make the other birds feel less than. Rumor has it she pegs her husband to get what she wants (Google it). Her decorator is a big, loud, bitchy blue jay. When they drink chardonnay together,

they secretly pop her kid's Adderall and get white foam in the corners of their mouth and gossip about the other bird's husbands getting vasectomies. They smoke cigarettes and do anything they can to have diarrhea 24/7, because skinny birds have diarrhea. Mary Francis loves luncheons and tennis. She has a panic attack if she's not invited to everything and secretly thinks everyone is out to get her. She seems friendly, but is toxic and extremely passive-aggressive. She will attack unprovoked. Use caution when approaching.

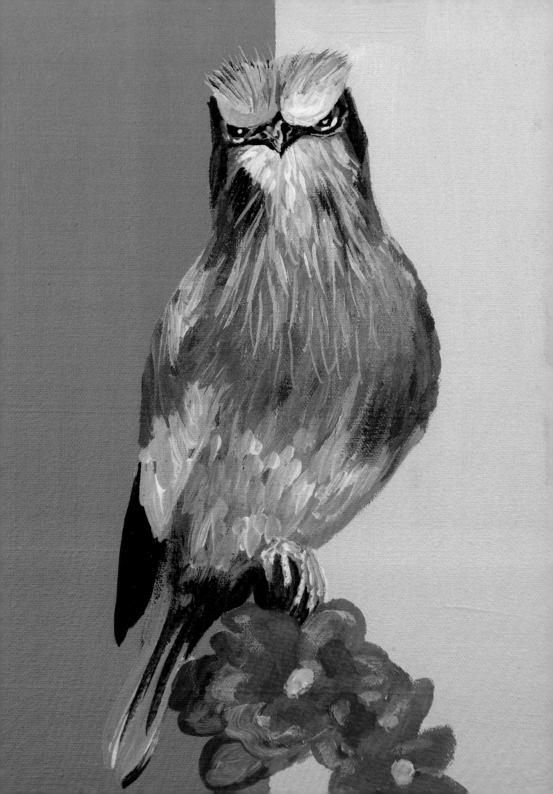

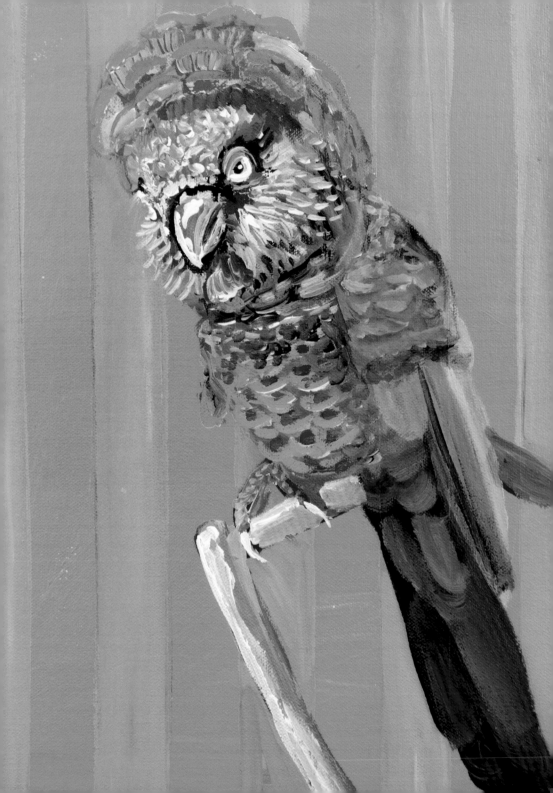

Armand

Armando stylissimo

Meet Armand. He lives in a nest above a salsa dance studio. He knew he was special in high school when he mastered cutting bangs on the girls in drama class (he calls that his first gang bang). He memorized all the choreography to Britney Spears's "...Baby One More Time" and, when given enough tequila, will perform the whole damn thang at the whisper-level of "oh, baby, baby." Armand can spot fake bags from a mile away and he gets nauseous when he sees foam platform flip-flops. He had to be taken to the hospital once because he tried to give himself a bikini wax with a DIY kit. He had to have his best friend Jean (pronounced Shawn) disable his Grindr account because it became a problemo. Lil' Bang Bang can COOK. His specialty is Cuban food, but he has also mastered cooking up trouble. He is not easily provoked, but if he chirps "LET ME TELL YOU SOMETHING, HONEY," shit's about to go down. Armand wears sequins to brunch and is helpless in front of a bottomless mimosa. Overall, Armand is a very approachable bird. He is fun and loyal, but do not approach with platform flip-flops or a perm of any sort.

Mary Pat

Marypatorius kegelsmaximus

Meet Mary Pat. Mary Pat is a 4.0 on the tennis court. She does Kegels during spin class to keep her shit tight so her hubs won't run off with Mary Kate. She gags on her husband's dick so he will be the highest bidder in the silent auction to skip the carpool line at her kid's school for the year. Her man overlooks her Saks Fifth Avenue bill because she gives him a pinky to the second knuckle at least twice a week. Mary Pat is also the fat police; she watches what everyone eats and keeps at least a decade-long catalog of what they have ingested. She has not had carbs since she drank chocolate milk on a Friday in the first grade. She wears heels to lawn parties and chaired the BIG event to save the town's biggest, most pretentious garden just to show off her own house. Mary Pat drives a G-Wagon and wears athletic wear by day and Hervé Léger by night. BEWARE of Mary Pat. She is a scary, dangerous, high-strung bird that will attack on sight.

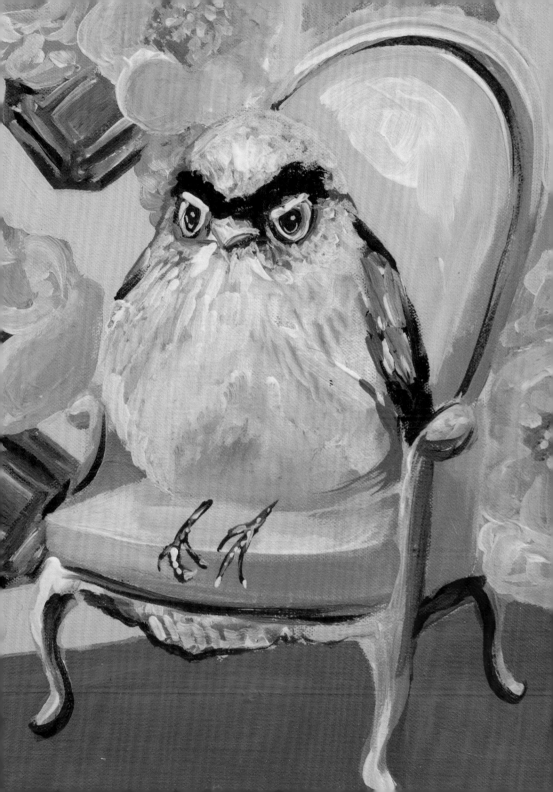

Beverly

Beverlya bitchya

Meet Beverly. She's a fucking bitch. She won't let the other chickens eat and she pecks at them if they get shit on their feet. She is being nominated for the president of the garden club. Her disposition is PERFECT for it. BEVERLY FOR GARDEN CLUB PREZZIE! How many clucks do we give? NONE. NOT ONE! Only Beverly could make growing a maidenhair fern bitchy. Beverly will cluck her way to the top.

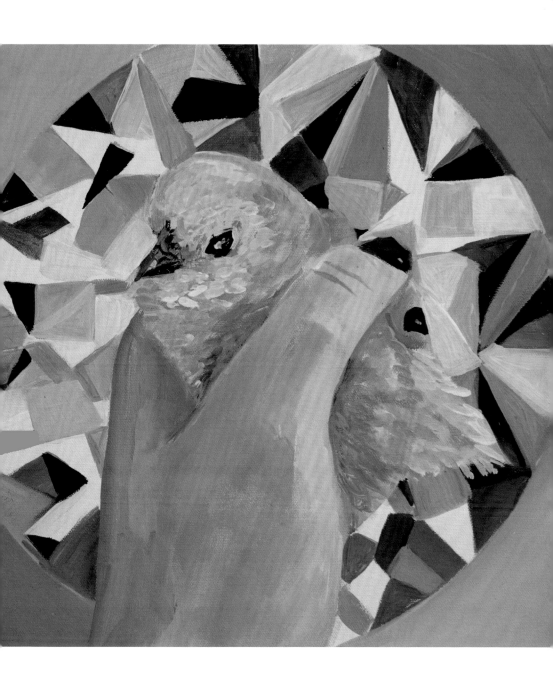

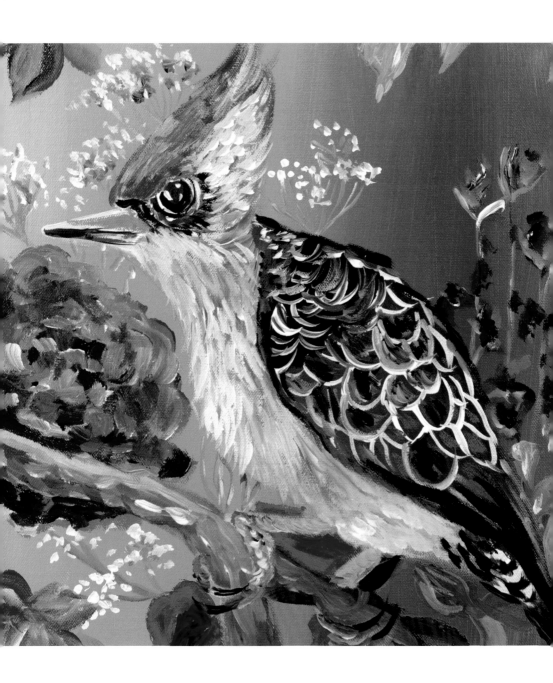

Muffy

Muffy lispera

Meet Muffy. She lives in a nest above her neighborhood's private tennis club. She studied abroad in London while in college and now calls her powder room the loo, refers to the movies as the cinema, and wears trainers instead of tennis shoes. She has a mild lisp that gets much worse after her third glass of rosé. Her stages of drunkenness are always the same: in stage one she thinks she can sing, in stage two she thinks she can dance, and in stage three she thinks she is invisible. During the stage three invisibility, Muffy really lets it all out. She told her best friend that her husband should get "snipped," and she snorted her eleven-years-old son's Adderall in the women's lounge at the country club. Then she called out the president of the Junior League for being married to a gay man.

Poor Muffy did not get into the garden club. Her housekeeper calls her "a Depp'll do ya," because she got caught masturbating watching Captain Jack Sparrow in *Pirates of the Caribbean: The Curse of the Black Pearl* after her tennis clinic. Muffy's face is always a few shades lighter than the rest of her body because she gets chemical peels often and rarely leaves the house without a visor. She drives a Land Rover and brags about being able to talk on the phone, do Kegels, activate Siri, call OnStar, parallel park, yell at kids, and listen to Adele simultaneously. Muffy is a relatively harmless bird, but she is not to be trusted and is known to be rather stroppy. Approach with caution.

Carol

Carolomius hotmessimus

Meet Carol. Carol lives in a nest outside of a condo building located between an Applebee's and a karate studio. Carol is VERY aggressive and will take off her shoes and earrings and get all up in your face. She thinks leggings are pants. She drives a 2003 Toyota Corolla. She has a bumper sticker that says, "CAUTION: I Go from Zero to Horny in 2.5 Beers" and another that says, "Sorry for Driving So Close in Front of You." Carol is a self-defense expert and is currently writing a book called *500 Ways to Kick Someone in the Balls*. She sleeps with a pot of boiling water on the stove in case someone breaks into her condo—she can throw the water on the intruder and then give them a swift kick in the 'nads. Carol's favorite band is Danzig. Her favorite naughty snack is Vienna sausages with Cheez Whiz. Carol thinks underwear is a marketing scam. She also watches *Wheel of Fortune* every day at 6:30 p.m. and screams at the television when people don't know the answers. Caution: Carol is an extremely volatile bird. I would be seriously careful around her.

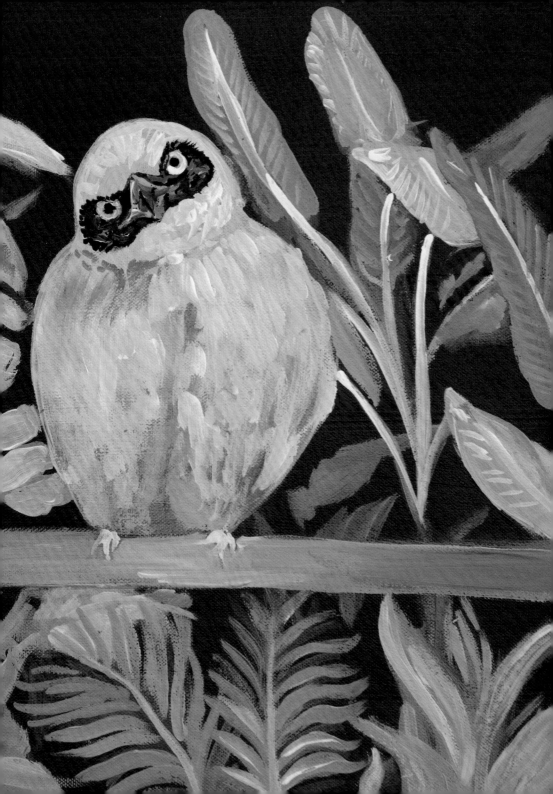

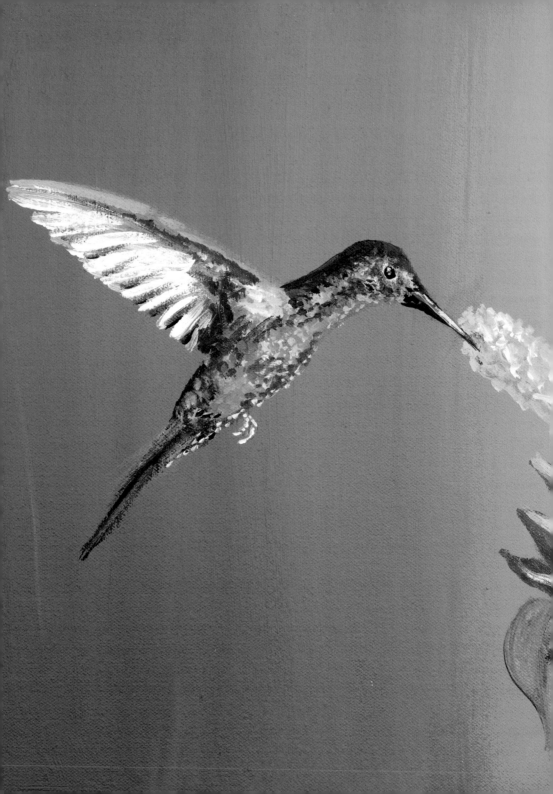

Victoria

Victorius victoriamaximus

Meet Victoria. She is the boss of the trees, the boss of the bees. Bow down to her beauty, get on your knees. If she gets in your face and wags her wings, bow down bitch, that's how she runs things.

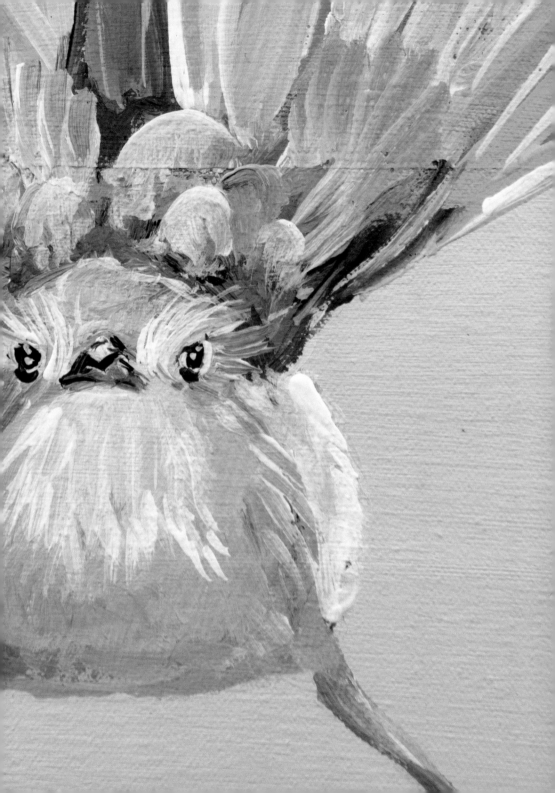

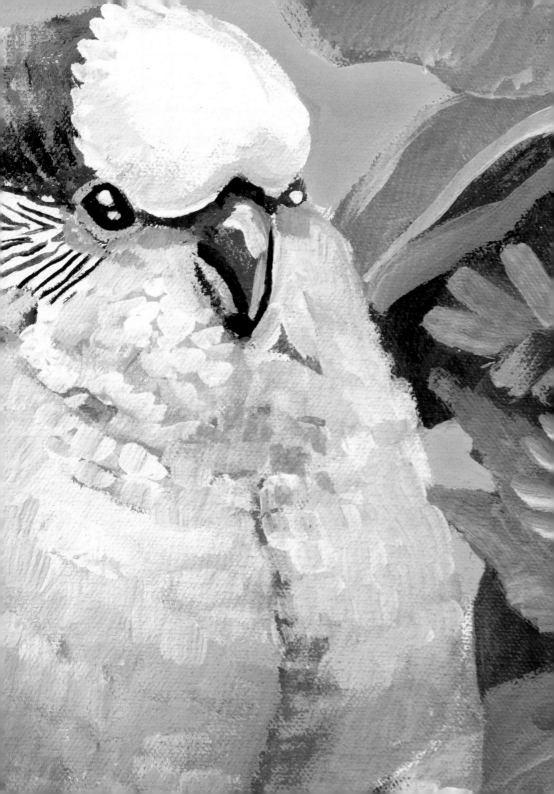

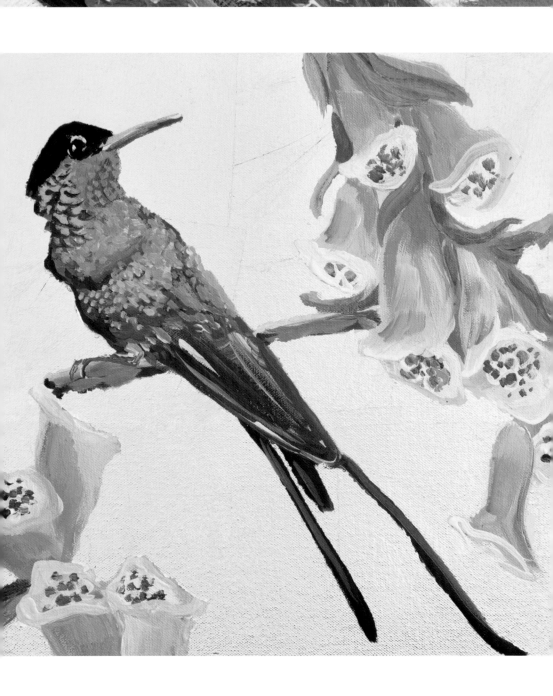

Courtney

Courtnelius buzzoramus

Meet Courtney. Always the skinniest
and the prettiest. She eats all fucking day
and never gets fat, that bitch. She needs
to chill, always zinging around, catching
a buzz. She is a nervous, erratic bird, but
it's always fun to see her hogging out on
flowers. No but really!

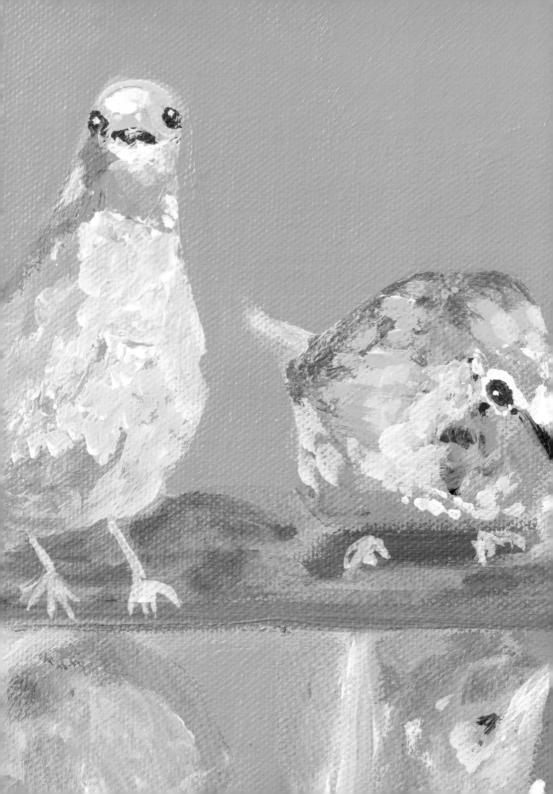

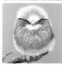

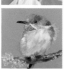

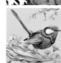
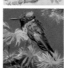

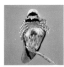

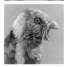
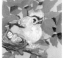
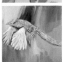

First published in the United States of
America in 2024 by
Rizzoli Universe
A Division of Rizzoli International
Publications, Inc.
300 Park Avenue South
New York, NY 10010
www.rizzoliusa.com

Publisher: Charles Miers
Associate Publisher: Jessica Fuller
Assistant Editor: Emmaline Dixon
Design: Tony Lecy-Siewert/GCA
Production Manager: Colin Hough-Trapp

Printed in Italy

2024 2025 2026 2027 / 10 9 8 7 6 5 4 3 2 1

ISBN: 9-780-7893-4553-0
Library of Congress Control Number:
2024931252

Visit us online:
Facebook.com/RizzoliNewYork
Twitter: @Rizzoli_Books
Instagram.com/RizzoliBooks
Pinterest.com/RizzoliBooks
Youtube.com/user/RizzoliNY

MIX
Paper | Supporting
responsible forestry
FSC® C084761

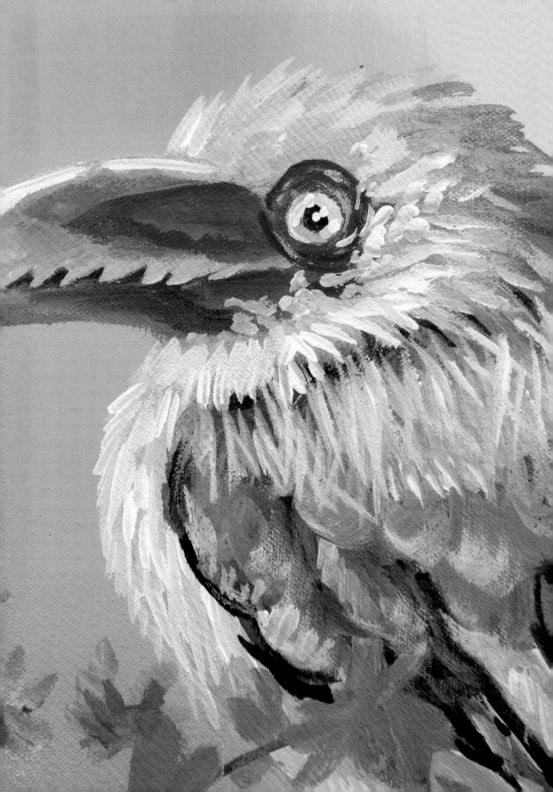

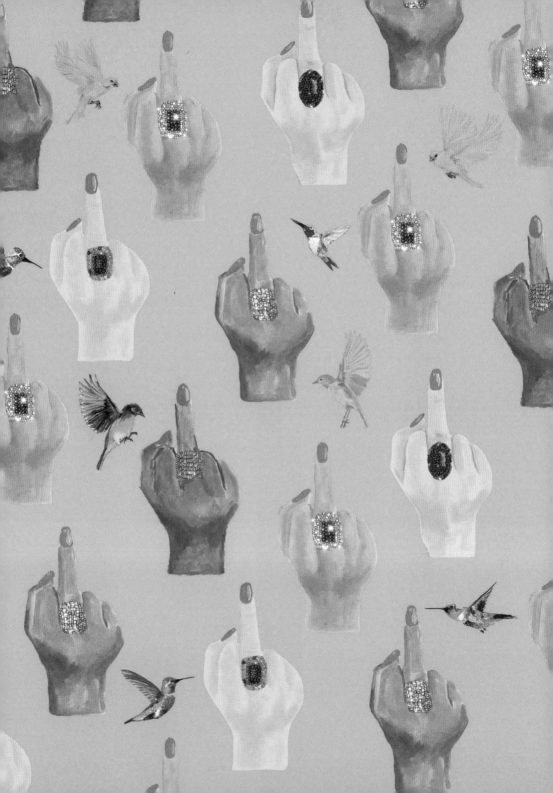